DIGITAL

black and white photography

A step-by-step guide to creating perfect photos

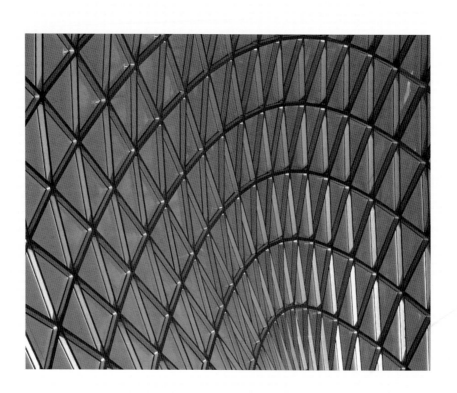

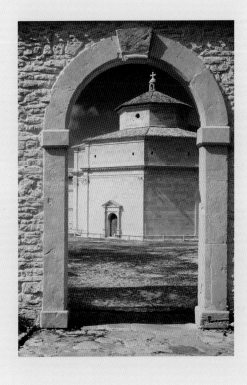

DIGITAL

black and white
photography

A step-by-step guide to creating perfect photos

JOHN BEARDSWORTH

THOMSON
COURSE TECHNOLOGY
Professional ■ Trade ■ Reference

For Course PTR
Publisher: Stacy L. Hiquet
Senior Marketing Manager: Sarah O'Donnell
Marketing Manager: Heather Hurley
Associate Marketing Manager: Kristin Eisenzopf
Associate Acquisitions Editor: Megan Belanger
Manager of Editorial Services: Heather Talbot
Market Coordinator: Amanda Weaver

ISBN: 1-59200-472-5

5 4 3 2 1

Library of Congress Catalog Card Number: 2004109686

Educational facilities, companies, and organizations
interested in multiple copies of this book should contact
the publisher for quantity discount information. Training
manuals, CD-ROMs, and portions of this book are also
available individually or can be tailored for specific needs.
COURSE PTR,
A Division of Thomson Course Technology
(www.courseptr.com)
25 Thomson Place
Boston, MA 02210

This book was conceived, designed, and produced by
The Ilex Press Limited
Cambridge
England

Publisher: Alastair Campbell
Executive Publisher: Sophie Collins
Creative Director: Peter Bridgewater
Design Manager: Tony Seddon
Editor: Adam Juniper
Designer: James Winrow
Artwork Administrator: Joanna Clinch
Development Art Director: Graham Davis
Technical Art Editor: Nicholas Rowland

Printed in China

For more information on this title please visit:
www.ssbwus.web-linked.com

Contents

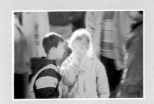
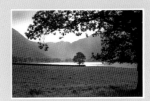

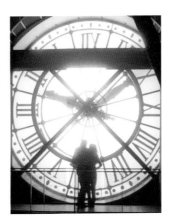

Introduction

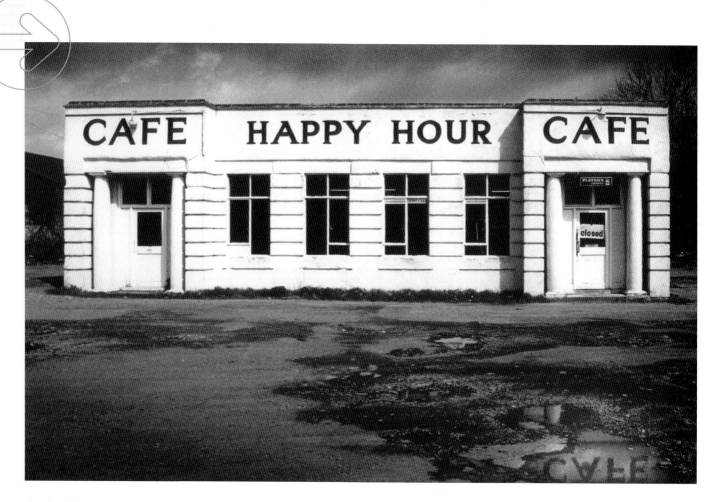

In its history, now stretching back over 150 years, black and white photography has survived the rise of color and continues to hold its respected position alongside the color print and transparency. Old prints may have turned sepia, but as an art form, black and white photography refuses to fade away. Photography has survived the moving picture, outlasting silent cinema, black and white television, and numerous video formats. There remains the desire to freeze the decisive moment or express what one saw as a still photograph. In the press, commercials, fashion, and art, black and white is still going strong.

The means of capturing and then displaying the image have always been in a state of change. Metal plates, various types of film and paper—most of all silver-halide based—have come and gone, usually surviving in some form. Simple manual cameras are still made, alongside the sophisticated, computerized machines of today. Photographers still need to understand their tools and their craft in order to express themselves creatively.

This was very much the philosophy of the photographer Ansel Adams, and one of the pleasures of writing this book was the opportunity to re-read his manuals, *The Negative* and *The Print*. While mainly known for his supremely "realistic" black and white images of Yosemite and the American West, I also have a book of his color photographs. So it was fascinating to read that in 1981, he

An English roadside truck stop takes on a very dramatic look when photographed in black and white, though the only digital enhancements were to remove foreground clutter.

 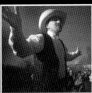 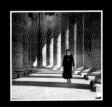

Black and white is still going strong half a century after the introduction of popular color photography. There is no need to view them as mutually exclusive; digital lets you try both.

A display in a less-than-promising gift shop in Southern Italy becomes almost iconic in this composition.

wrote, "I eagerly await new concepts and processes. I believe that the electronic image will be the next major advance."

While stressing the continuity of black and white photography, it is hard not to be excited by the digital age. For many photographers, black and white was their first love; in my case I've been hooked since seeing pictures develop in the school darkroom. But the world is too beautiful to never photograph it in color, and digital photography means we no longer need to choose between color and black and white.

This book has three parts to its title: digital, black and white, and photography. Partly, these may be combined—section 1 deals with digital photography equipment, section 2 is essentially about black and white photography, sections 3 and 4 address digital photography in the sense of the "digital darkroom." Section 5 is concerned with the digital black and white photograph, the final product, print, presentation, or image on the Web.

Introduction

Light plays a distinct role in black and white photography; compositions use the shape of the subject, rather than splashes of color, to lead the eye.

Digital black and white photography is a broad topic and includes any image that could be produced in the black and white darkroom, but instead is output via the computer. Obviously it includes using a digital camera, but it also involves scanning film or prints. It includes camera techniques common to both film and digital, but photographers now also need to learn about and how to use image file formats and highlights alerts.

The main thing is to avoid thinking of black and white as simply the original image minus the color. There is no need to explain how colored lens filters are used with black and white film, but the photographer can now use the same principles to carefully control how Photoshop converts a color image to a black and white one.

Ansel Adams once wrote about the negative as a musical score and the print as its performance: Black and white photography has always been about using the darkroom to produce the print. Photoshop skills included in Chapters 3 and 4 especially focus on darkroom equivalents such as dodging and burning,

Digital black and white photography is about more than removing the color—it is about understanding light and sharing your knowledge.

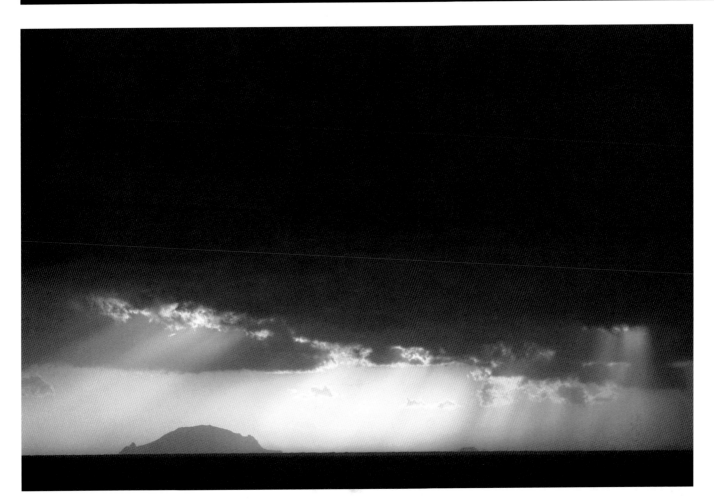

masking, variable contrast, split toning, and solarization. We are not falsifying the image in Photoshop, but using the software as the main instrument in the digital darkroom.

My own route into digital photography was "wet-dry," scanning film, and slowly abandoning the darkroom while also learning how to use Photoshop. I waited a long time before getting a digital camera, and when I did I was surprised by two parallels with Polaroids, the instant photographs that once seemed so amazing.

The first parallel, one that was easy to anticipate, is the benefit of instant feedback. Just as the professional studio photographer uses Polaroids to check exposures, digital

In an image like this, there is little need for color. The subject—the pattern of light illuminating the island—is captured here.

With digital, it's also possible to experiment with dramatic and unusual effects in monochrome.

Introduction

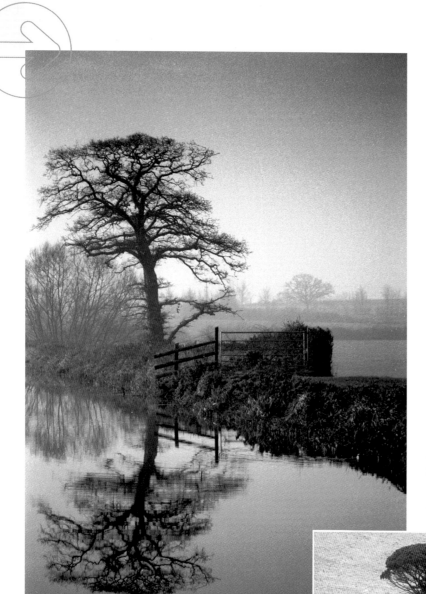

cameras mean you can check results immediately. This has a deeper benefit than simply letting me reshoot the picture with correct exposure and maybe better composition. Not being one of those photographers with a notebook for exposure details, it could be hours, days, or weeks before I saw the pictures, by which time I had forgotten what I had done. Sometimes it was possible to guess, but I learned so much by reviewing the EXIF data stored for each digital image. Soon after starting to use a digital camera, I noticed a clear improvement in the accuracy with which I was able to assess how much overexposure or underexposure a particular scene required. For someone with 15 years of photographic experience, this was quite a revelation and convinced me that the very nature of the camera itself helps photographers learn and improve.

Secondly, as with Polaroids, digital makes photography something you can share with your subjects. This was something I first noticed when photographing children. My five-year-old

Details in landscapes, like this tree in a field in Tuscany, can be picked out with a long zoom lens.

A reliable composition technique is the "rule of thirds," where two horizontal and vertical lines divide the image into a nine-rectangle grid. The subject, in this case the tree and its reflection, lies near the intersection of the thirds.

Learning and improving on black and white skills will enhance your photography in general, especially using the extra information digital provides.

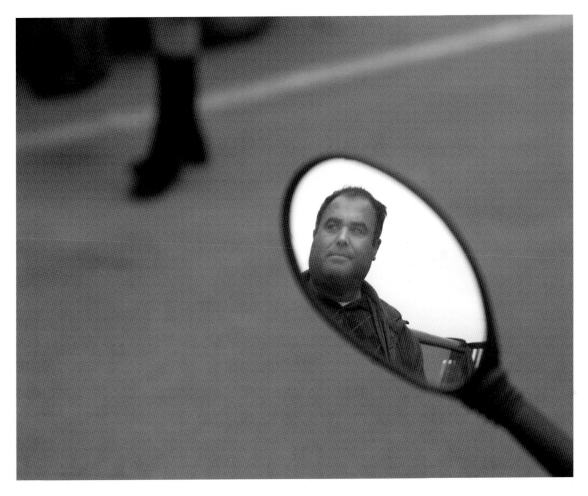

This photograph gives a little bit of insight into the object of the subject's attention: the woman whose boots we can see in the background.

niece loves being photographed, eagerly gives her opinions on each shot, and very much participates in the process. Photography seems to be an important connection between us—and it's hard to imagine making that connection via film. Another example happened just a short time ago in a market in Calabria, in Southern Italy. After I showed a candid shot to my subject, he let me take a portrait, and this led to a morning photographing the traders. They could see the results and were more than willing to keep posing. The banter was what I love about the country. In short, digital is not just another dry technical development in the history of photography. The digital camera itself lets you share the fun of photography.

Pattern and symmetry can be seen everywhere. It is worth learning how to isolate things with your camera.

1 Your Digital Camera

Photographers were initially skeptical about digital when it first surfaced as a replacement for tried-and-true silver-halide film. Digital cameras were seen as little more than novelty items. Now, however, they are every bit as sophisticated as their film counterparts, with many of the same or similar features. It is well worth getting familiar with this functionality and the results it offers, which is what this chapter is about.

Camera and image resolution

Digital cameras capture images by recording light hitting an imaging sensor behind the lens. To record sufficiently rich color tones, the sensor consists of a filter system, microlenses, and millions of light sensitive dots, or "photosites." Each photosite is only sensitive to red, green, or blue. They are laid out in patterns and the camera interprets this data and creates an image consisting of picture elements, or pixels, each of which has red, green, and blue values.

This image information is captured in a RAW data format that is usually proprietary to the camera maker, and that may even vary between different models from the same manufacturer. Digital SLRs, and better equipped cameras, let the photographer choose to save the RAW file intact. Some can save the image as a Tagged-Image File Format (TIFF), a generic format that can be read by many computer programs and operating systems. Most cameras can save the image as a Joint Photographic Experts Group (JPEG) file, a compressed format that selectively discards data. The camera processes the RAW data and outputs the JPEG file. Processing includes sharpening the image, approximating similar colors, and applying other user-definable settings such as color corrections to deal with artificial light sources. Compression is achieved

through discarding unused data, which is why JPEG is known as a "lossy" format. To produce a smaller JPEG file, the camera processor makes more approximations and loses more image information. The image file is then written to some form of removable memory, such as a Compact Flash card.

In general, for image quality, use RAW format if your camera has one. If you create very large volumes of images, JPEG is better, but this is only really true if they must be transmitted rapidly and with no post-camera adjustment, for example when news journalists are wiring images back to the office.

WHICH FILE TYPES TO USE	RAW	JPEG
CAPABILITY	If your camera has a RAW option, this is normally the better choice.	Some cameras have no RAW format, so use the best-quality setting.
QUALITY	The maximum image data is retained, so you can produce the best possible black and white photograph.	Once image data is lost, you cannot get it back.
FILE SIZE	Big. If this is a problem, get more memory or hard-disk space. You should never be caught in the field with too little memory, but switch to JPEG if this happens.	Smaller and more efficient, so better if you take lots of pictures, and need to email them over restricted bandwidth.
FINISHED IMAGE IN CAMERA SOFTWARE	The RAW file is a digital negative, not the final photograph. To work with this kind of file, use the software that came with the camera or a third-party application like Photoshop CS's Camera Raw.	Better if you want no manual intervention after the picture is taken. All imaging software handles JPEG files.

Understanding more about image resolution and file formats can help you get more out of your digital camera.

FACT FILE

Image resolution

It is easy to get confused by pixels and dots per inch, or dpi. Remember that pixels are the true dimensions of an image, and dpi is simply a file header that is sent to any output device. For instance, a 2,700 dpi scanner can turn a 35mm slide into a digital image 3,600 pixels wide. Most monitors have a resolution of 72 dpi, so viewing this image full size would require a screen 50 inches wide (3,600 divided by 72). Printers typically output at 300 dpi, so the full-size image would produce a print just over 12 inches wide. Whatever the output resolution, the image remains 3,600 pixels wide.

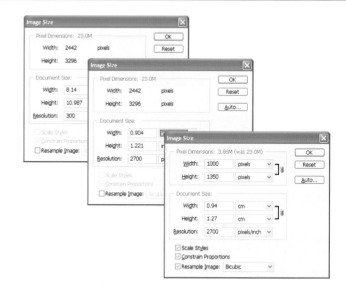

	RAW	JPEG
ARCHIVING	Consider using Photoshop or another program to batch copy all RAW files as TIFF or JPEG. Store these separately as a backup just in case the RAW format is unreadable.	Normal archiving rules probably apply.
WRITING TIME	RAW takes longer to write to the removable memory, though cameras' buffer size is continually increasing.	Better when you need to shoot many pictures in a burst, such as when trying to shoot a burst images for a multiple exposure.
SHARPNESS	Images are initially softer, but you have finer control sharpness on the computer.	Out of camera, JPEG is sharper.
THIRD PARTIES	If you need to send an image file to someone else, RAW formats are not universal. However, you can always convert the RAW to JPEG on computer.	Widely acceptable at commercial photo printers and on the Web.

TIP Even if you plan to email images, take them at higher quality, then use your computer to reduce them, keeping a good copy.

The camera and its controls

Digital cameras come in a great many shapes and sizes, but the underlying principle is essentially the same: An image is recorded from a sensor onto a reusable memory card of some kind. To get the best results, you should become as familiar as possible with your camera's implementation of the following features.

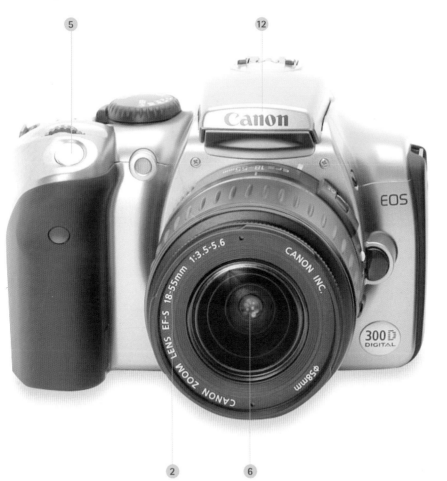

1 Focus modes
Many digital cameras can switch to different parts of the viewfinder for focusing. Also, a camera should allow manual focusing, and a continuous focusing mode is useful for action shots.

2 Lens/digital zoom
With zooms, the optical zoom range is important; digital zoom is not.

3 LCD screen
The LCD screen is one of the most important differences between digital and film photography. While power hungry, they let you check your results immediately.

4 Viewfinder
Better digital cameras allow you to view the subject through the viewfinder. Really valuable options can include grids, great for photographing buildings, and blown highlights alerts, which warn you when the exposure has captured no detail in the brightest part of the image.

5 Shutter release
Most digital cameras have shutters. Look not just at the fastest shutter speed, but at the slowest. A 15-to-30-second speed is essential, and it is also good to have a bulb setting, where the shutter stays open as long as the shutter release is pressed.

6 Aperture
The aperture is the hole in the lens through which light passes. A small number, such as f2, indicates that the lens can be opened very wide, and is better when the light is not so good.

There is a great deal of variety among digital cameras, and the features are often tucked away in menus. Check your manual.

❼ Exposure mode

Most digital cameras allow the photographer to set exposure to auto, aperture priority, shutter priority, and manual.

❽ Sensitivity

The higher the ISO setting, the more sensitive the sensor is to light. While there is a loss of image quality at higher settings, digital cameras let you vary the sensitivity for each shot.

❾ White balance

Most cameras have preset modes that allow you to compensate for the color of artificial light, which will be much more obvious on a photograph than in reality.

❿ Battery

Rechargeable batteries are the norm, as well as being better for the environment. It makes sense to keep a charged spare battery in your camera bag.

⓫ Storage

Digital cameras use small flash memory cards such as Compact Flash (CF), Smart Media, Sandisk (SD), and the Memory Stick. Some also accept the Microdrive, a small hard drive. Reliability is improving, but a few small cards are safer than one big one.

⓬ Flash

Most cameras have a small built-in flash. These can be invaluable, though separate flash guns are needed for more advanced work. (In this case, a pop-up flash is activated by button 13.)

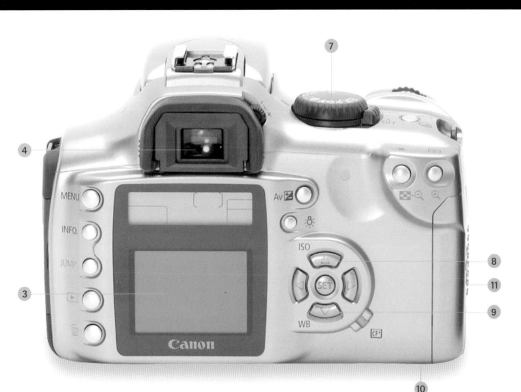

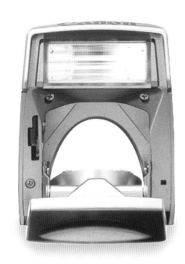

FACT FILE

Exposure metering

Better cameras have more ways to select which parts of a scene are important for setting exposure. Look for matrix, center-weighted, or spot modes.

Sensor

Most digital cameras record images using a sensor consisting of millions of photo diodes. The sensor is usually smaller than 35mm film and is generally measured in megapixels, or millions of pixels.

Capture modes

Most cameras allow you to capture images in different file formats. Unless you shoot lots of pictures, and need to print or transmit them quickly, use the highest-quality mode and get more storage. Low-end cameras usually offer JPEG, where high quality is traded off for small file size. Better cameras can save as TIFF, where all image data is saved, but the best-quality format is RAW.

The lens

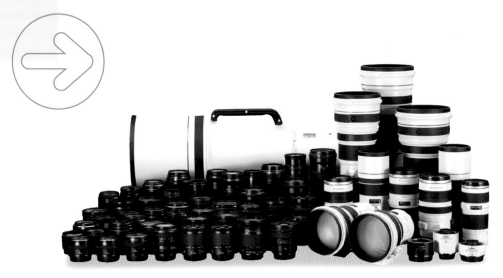

There is a huge variety of lenses on the market. These are Canon's offerings, all of which can be used with the EOS-300D shown on the previous page.

Many photographers feel they get more from buying better lenses, rather than getting the latest, most expensive camera body. It's no bad thing to stand back from the marketing rush, and lenses usually outlast camera product cycles, so it is a perfectly reasonable point of view.

Digital photography does not mean throwing out old lenses. Camera manufacturers have always tried to ensure that their existing lenses will function on new bodies, but there have also been points, such as the introduction of autofocus, when some have introduced wholly new lens systems and sacrificed backward compatibility. The onset of digital photography is another of those points. Some manufacturers have kept compatibility with existing lenses while also producing lenses "designed for digital." Others have accompanied the introduction of their first digital SLRs with completely new lens mounts.

While much remains the same, digital photography challenges some long-held assumptions about lenses, and some rules need to be relearned.

ZOOM OR PRIME LENSES?

Zoom lenses are usually slower and bulkier than prime lenses of similar focal length. On the other hand, zooms allow more flexibility to compose the final image in the camera. This matters more with transparencies or when the photographer has no control over the printing process. Digital photography is all about "post-processing" images on the computer, so maybe there is less need to compromise, and a prime lens is a better choice. This though is a matter of personal taste.

FOCAL LENGTH

Most digital cameras' film sensors are smaller than the traditional 35mm frame. So, when the camera focuses the image onto this smaller area, it alters the optical characteristics of a lens designed for 35mm film. Usually this is expressed as a multiplier of around 1.5, so a 70–210mm digital zoom becomes equivalent to a 100–300mm lens on a 35mm film camera, allowing you to zoom in closer to your subject.

In the other direction, this affects the angle of view. A 20 or 24mm lens, which was wide angle on a film SLR, is no longer so wide on a digital SLR. While there is an advantage—the picture is recorded using the best, central part of the lens—this is unsatisfactory from a pictorial point of view. Manufacturers have responded by releasing new wide-angle lens designs with focal lengths as short as 12mm. Flare is often a problem with wide-angle lenses, so always use the manufacturer's lens

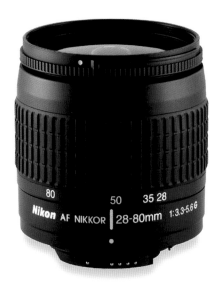

A typical SLR autofocus zoom lens from Nikon.

hood, and consider getting a flare buster, a cheap holder that fits into the hot shoe, allowing you to protect your lens with pieces of card.

CAMERA SHAKE RULE

Camera shake, due to using too low a shutter speed, can wreck a photograph. There are expensive lenses with gyro-based image stabilization systems, and some photographers have exceptional steadiness of hand. But many photographers use a rule of thumb and match focal length to shutter speed: With a 50mm lens, use a speed of at least 1/50 second.

Whether picking out detail or capturing a whole scene, the choice of lens (where lenses are interchangeable) is every bit as important as the camera.

The digital multiplier changes this rule. Unless a digital camera has a "full frame" sensor, the 50mm lens acts like a 75mm lens on 35mm film camera. So you also need to multiply your safe shutter-speed rule by 1.5 and can handhold a 50mm lens at least 1/75 second, or rememeber your lens's equivalent focal length.

Pointing a wide-angle lens upward may cause converging verticals, but the results can be attractive.

Lens makers have released new lenses optimized for digital cameras. While this may have advantages, there is a limitation: If you use these lenses on a full 35mm frame camera, there is much stronger "vignetting," or darkening, in the corners of the frame.

Consider instead the new wide angles not specifically designed for digital cameras. The wide-angle lens used for this picture was a 14mm I bought to go on my digital SLR, but some of its best results have been on a film camera, where its angle of view is truly spectacular.

A 70-200 zoom lens allows you to pick out details and turn a scene into an abstract image. This lens was used at 140mm on a digital SLR and with a shutter speed of 1/500 second. Hand holding would not have resulted in a sharp image below 1/250 second.

Focusing

To get a sharp picture, you need to hold the camera steady and have the image in focus. Digital photography can apply sharpening and make lack of focus less damaging. Alternatively, a special effect can sometimes rescue something attractive from the image. But the image remains dissatisfying and the photographer always has a nagging sense of failure.

Focusing is partly a routine technical task that the modern camera does for the photographer. Since its introduction in the 1980s, autofocus has become ever faster, more sensitive, and more accurate in all sorts of lighting conditions and with more rapidly moving subjects. Now even expensive medium-format systems are available with autofocus, and it is scarcely imaginable that a manufacturer would design a digital camera without it.

Most autofocus systems work by measuring the contrast of light coming through the lens and move the lens elements until the image is sharp. This type of autofocus is known as "passive," as opposed to "active" methods such as detecting distance by bouncing an infrared beam off the subject. But focusing is much more than a technical matter. The photographer has the opportunity to make creative and aesthetic decisions whenever the shutter button is pressed.

How much of the image is in focus can be carefully controlled, depending on lighting conditions, sensor sensitivity, or on the photographer's choice of lens type, aperture, and shutter speed.

Not all the image needs to be in focus—depth of field can be used to concentrate attention on the subject or to hide distracting background images.

Depending on the lighting conditions, or the photographer's choice of lens type, sensor sensitivity, aperture and shutter speed, not all the image can be in focus.

TARGETING

Before every image, ask yourself what you want to focus on. Then press the shutter-release button gently to focus on it. Hold the shutter release in its half-down position as you recompose the picture, then press the button to shoot. If your camera has multiple focus areas, consider switching to the focus area that minimizes the need to recompose. In pictures of people and animals, it is especially important to focus on the eyes. In some circumstances, the camera "hunts" for focus, and keeps moving the lens forward and backward. This may be because the focus area has such low contrast that the camera cannot determine when the light is focused. Hunting may also occur if you try to focus on a horizontal pattern, and the camera's sensors are also horizontally aligned. Try focusing on a nearby part of the scene, and then recompose.

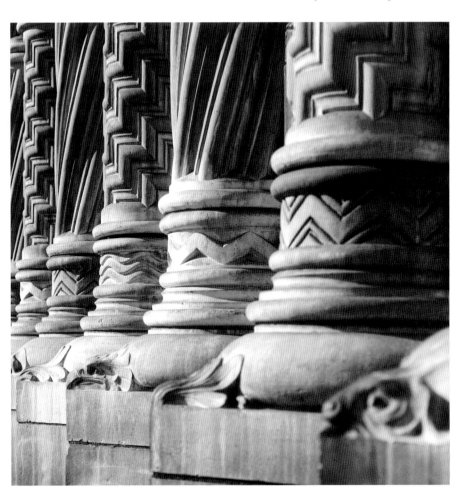

Here, focusing on the eagle and setting an aperture of F3.5 draws the viewer into the photograph but emphasizes the context of the shot.

Autofocus cameras handle the routine task of focusing. But the creative photographer remains in control and chooses what to focus on, and how to use depth of field to control how much of the picture is in focus.

DIFFERENTIAL FOCUS

Differential focus is another technique where you focus on an object but deliberately set an aperture that makes nearer objects out of focus. This has many uses, such as blurring ugly foreground objects.

Depth of field is multiplied by a factor of around 1.5 if you are using a lens designed for a 35mm SLR with a digital camera with a smaller sensor. If your camera has a depth-of-field preview button, press it and check in the viewfinder how much of the image is in focus at different apertures.

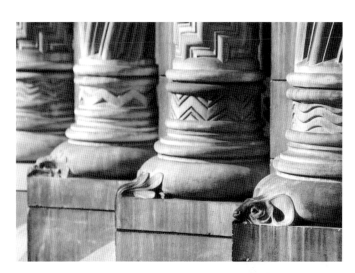

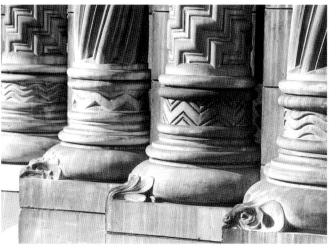

FACT FILE

LCD displays
Ⓐ The LCD display on the back of your camera places a heavy drain on the battery. Many cameras have an option to turn it off, which you may find useful.
Ⓑ Some cameras, however, dispense entirely with a traditional viewfinder, like the Sony camera shown here.
Ⓒ Be wary of the color reproduction. LCD is not perfect, especially in bright conditions.

◀ *Here, the pillar photograph with the f2.8 apertures has a short depth of field, and only the nearest animal in focus.*

◀ *Using f9 widens the depth of field, making it possible to focus on all the pillars at the same time.*

TIP Digital cameras' LCD screens often let you zoom in. Use this feature to check the focus after you have taken the picture.

Getting the right exposure

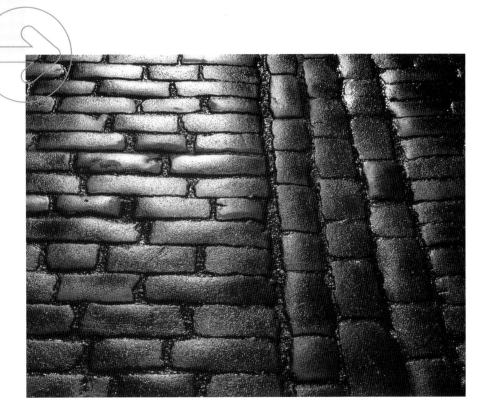

Here, the near-black cobbles caused the camera to over-expose, and it was necessary to underexpose by three stops to retain highlight detail.

The sunset reflected off the water was very bright, so I overexposed by 1.33 stops.

Modern cameras have very reliable automatic metering systems, yet lighting conditions or a subject's color can sometimes mislead them, and it is not always possible to manually override a calculated exposure and repeat a shot. In any case, it is always so much more satisfying when you get it right the first time.

To know when you may need to intervene, it is important to understand the basics of how digital cameras calculate exposure. Through the lens or "TTL" (Through The Lens) metering systems evaluate light coming through the lens and assess its combination of highlights, midtones, and shadows. While the actual programs are much more complex, roughly speaking, the camera assumes that the subject is an average mid-gray and calculates the exposure necessary to accurately render the scene.

However, very dark subjects can make the camera overexpose the image because the program assesses the scene as darkly lit, and sets a longer shutter speed or opens the aperture. True blacks are rendered gray and, worse, highlights are overexposed, or "burned out" and contain no detail. To correct this, you need to override the program and underexpose. Set the camera exposure mode to manual or, alternatively, leave the camera in program mode and adjust the exposure compensation, maybe just a fraction of a stop at a time. In either case, you will need a faster shutter speed or wider aperture.

A light-colored subject or shooting into the light may make the camera underexpose. Like screwing up your eyes when going out into bright sunlight, the program closes the lens aperture too much or sets too fast a shutter speed. While they contain detail that can be adjusted on computer, the picture's highlights are rendered not as whites but as grays, and the shadows are "blocked up." To correct this, override the program and overexpose—a longer shutter speed or a narrower aperture.

If it suits your way of working, review the exposure on the LCD after each shot. A great idea is to see if your camera has a blown-highlights alert feature that flashes those parts of the screen where the highlights are overexposed. Usually this is an optional setting, but many photographers find the warning so invaluable that they leave it on all the time. In my view, this is one of digital's strongest features.

YOUR DIGITAL CAMERA

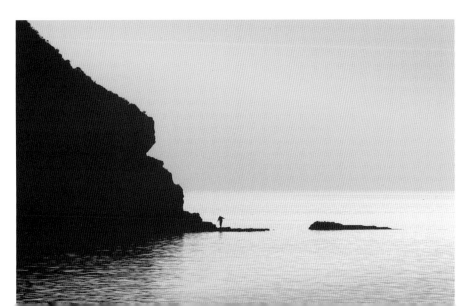

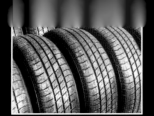
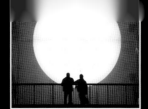

Understand how the camera computes the exposure, and learn when and how you need to override the program modes to achieve a better result.

If metering from the scene is difficult, try getting an exposure reading from an object nearby—grass or a mid-gray card can work well. Also consider switching to spot metering and pointing the camera at an average-toned part of the scene. Once you have an exposure reading, hold down the exposure lock or use the manual exposure mode, recompose the picture, and shoot.

Since digital cameras show you results immediately, separate light meters are less necessary nowadays. But they can still be worthwhile because they can be pointed back at the source of light falling on the subject, the incident light. Unaffected by the subject's own color and the reflected light, this way of assessing exposure is often more accurate than using TTL meters.

A special aspect of black and white photography is the importance of highlights. Burned out highlights are especially obvious in black and white, and all that can be done with them on computer is to somehow fake and cover up whatever detail is absent. Blocked-up shadows are significantly less distracting. So, if in doubt, underexpose.

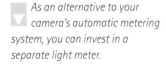
As an alternative to your camera's automatic metering system, you can invest in a separate light meter.

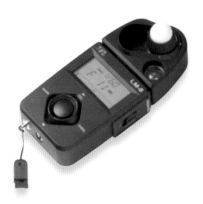

I had already taken a few shots of this scene and the LCD screen's highlights alert had warned me that the program's exposure had burned out any detail in the artificial sun. I had therefore been underexposing by one stop when the little girl suddenly danced into view. It was a completely unrepeatable shot.

TIP Digital cameras record exposure details and show under- and over-exposure adjustments. These can be an invaluable learning tool.

Look out for changing conditions. The clouds were moving quickly and sudden moments of brightness burned out the clouds' edges in some shots of this building.

The camera calculated exposure based on the bright sea. Overexposing by a stop kept detail in the railings.

Low light

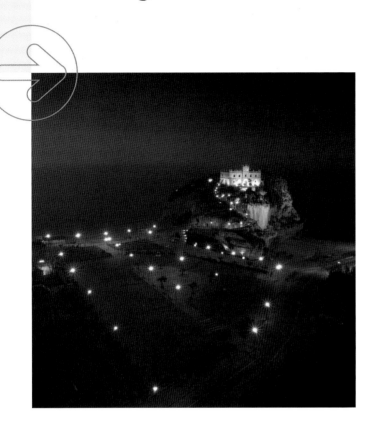

10 shots in 10 minutes as the sky turned from dark blue to black and the floodlights became relatively stronger. For the first shots it would have been possible to use a high ISO and hand hold, but using a tripod had overwhelming advantages. I was able to use the camera's lowest ISO setting to get the best image and minimize digital noise, and a long exposure, 20 seconds, was used with a small aperture (f16) to get maximum depth of field. The small aperture had the interesting effect of creating starburst effects around the streetlights (though this could also be achieved using a special lens filter).

After each shot, I checked the LCD screen's highlights alert to ensure the chapel was

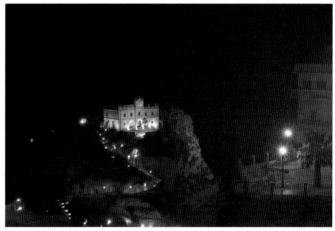

Low light creates problems for the photographer, making exposure trickier and increasing the risk of camera shake from too low a shutter speed. But it also brings great opportunities. Some of the most interesting light conditions are at the start and end of the day, when the light is weak, and many wonderful photographs have been taken in dismal weather, in dark locations, or indoors where natural or artificial light can often be much more attractive than flash. Freezing movement is harder, but blurred movement can often be more expressive.

At the end of the day, when the sky is still blue and contains detail, it is a great time to take night shots. Use a tripod, work quickly, and do not be afraid to take many shots—subtle differences may be visible when you view your pictures later on the computer.

In this series of shots, it was important to show that this chapel was on a rock by the Mediterranean, and at this time, the sea was just visible on the horizon. I took a sequence of

From a similar viewpoint, half an hour later, most of the detail around the subject is lost.

This was one of a sequence of 10 shots taken in 10 minutes as the sky turned black and the floodlights grew stronger.

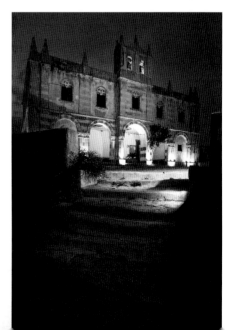

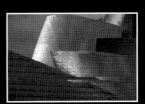

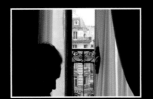

Digital cameras make it easier to get fine, atmospheric pictures in low light.

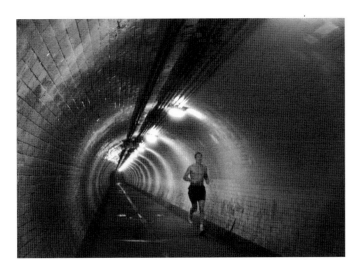

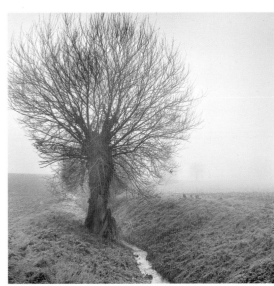

properly exposed and not bleached by the floodlights. This became more critical as the sky grew darker.

When the lighting conditions are difficult, it can also be a good idea to bracket your exposures. This is not simply in the hope that one of them may be right, but also gives you the chance to combine two different expo-sures, and this is much easier if the camera is mounted on a tripod and the images are correctly registered. It's not always possible or desirable to carry a tripod, however. A huge advantage of digital photography is that, if a tripod isn't an alternative, you can often get a sharp picture by increasing the camera's sensitivity and using a faster shutter speed. While film users could always change film mid-roll or adjust development and printing, this was inconvenient. But digital cameras let you change the recording sensitivity, the ISO setting, for each shot.

In this tunnel, shot without a tripod, the ISO setting was switched up to 1600 and allowed a shutter speed of 1/80 second, fast enough to hand hold.

These extracts are from a series of test shots at ISO 200 up to ISO 1600 and show the deteriorating image quality due to noise.

Taken in a foggy field early one morning, this was a negative that was scanned and then given a blue-green split tone to match the bleak December weather.

FACT FILE

What to look for in a tripod
Solidity should be a priority, and weight is important, too, but also pay attention to choosing the right tripod head. A ball-and-socket can be very versatile, but some prefer pan-and-tilt type heads that let each dimension be adjusted individually. It is a personal preference, so try out different modules.

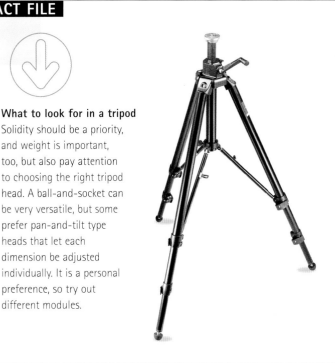

Using flash

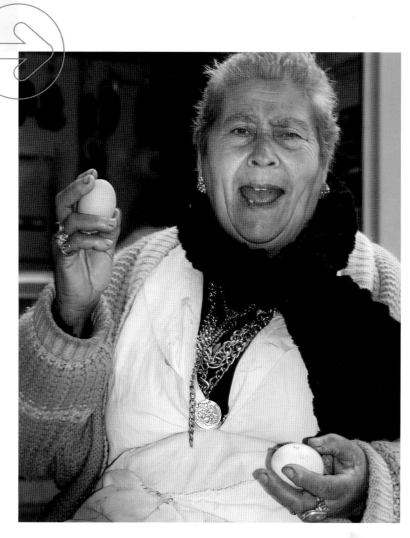

While cameras have integrated metering systems that monitor the exposure for you, using flash can still be a little unpredictable. After all, you are usually guessing how it will illuminate the subject and how the background will be exposed. Even when the photographer uses a cable release and is not looking through the viewfinder, the flash is over before the eye can scan more than a fraction of the scene.

Digital photography makes things easier than film in two ways. First of all, in low light, the need for flash is reduced because you can always increase the ISO so that ambient light is sufficient to allow a decent shutter speed for hand-holding the camera. Secondly, just as studio photographers often use Polaroids to preview images, the digital camera's LCD allows flash exposures to be reviewed instantly.

One thing to look out for is strong shadows caused by the flash. While in some cases they might not take much effort to soften in Photoshop, if you can identify them on the LCD screen, you might change the camera angle or move the subject and retake the shot.

Another reason to use the camera's LCD is that flash can burn out highlights or be visible as reflections off shiny objects and glass. When you take the picture, you will probably not notice it, but afterward it will be very obvious. If your camera has a highlights alert, the LCD screen will warn you when this has happened. Try moving position, or bouncing or diffusing the flash if possible.

Flash often adds attractive sparkle to eyes, but another issue to remember is that on-camera flash produces quite a flat image.

M ost cameras have small built-in flash units, great for casual use, and upmarket cameras also allow you to attach flashguns with more power. But don't just think of flash when it's dark. If contrast is high and the scene is backlit, flash can fill in or brighten up your subject. Flash can also be used to freeze subject movement.

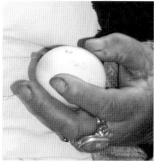

Most of the shots I took in this market in southern Italy were handheld, but this egg seller was a bit too enthusiastic. Notice, too, how dark the flash exposure made the background.

TIP The illuminating power of flash falls off with distance—at twice the distance, it will be a quarter of the strength. The relationship is inversely proportional to the square of the distance, so at four times the distance, it will be 1/16 as strong.

YOUR DIGITAL CAMERA

An advantage of the flash is that it gives the photographer control over where the light is coming from. If you have a separate flash gun, try using it from different angles or bouncing the light from another surface.

Sometimes you can get around this by bouncing or diffusing the flash, in which case the exposure appears much more the result of ambient light. If your flashgun does not permit this, inexpensive bouncers are available. Alternatively, use more than one flash, triggering the off-camera flashguns with small "slave" units that fit into their hot shoes and detect the light from the main flash gun. Another useful gadget is a PC socket adapter that fits into the camera's hot shoe and allows you to connect any type of flashgun.

You can review flash portraits in the LCD screen to see if the catchlights in the eyes and the overall sharpness outweigh the flatness of a subject illuminated by on-camera flash.

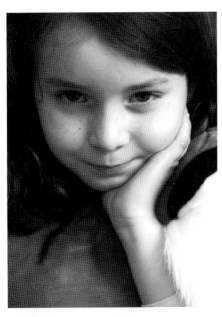

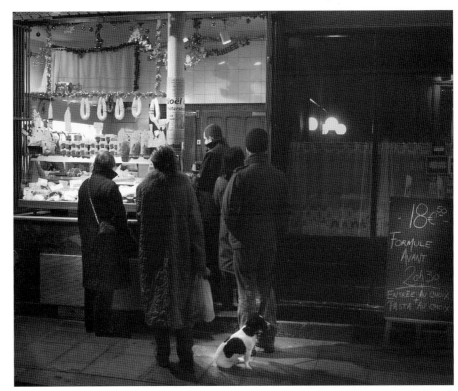

Although it would be possible to crop the reflection out of the flash-shot Paris butcher's shop, the handheld version has much more atmosphere.

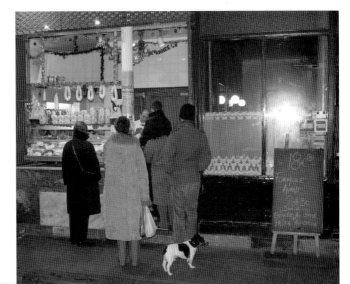

2 How to Shoot Great Black and White Photos

Good photography combines a degree of technical skill with the ability to view a scene from your own point of view. Composing a shot is probably the hardest part to master, since there is nothing in the camera's manual that can help you. In this chapter, we look at developing the ability to see, and capture, a great photograph. We can cover a lot here, but this is something that also comes from practice and experience.

Learning to "see" in black and white

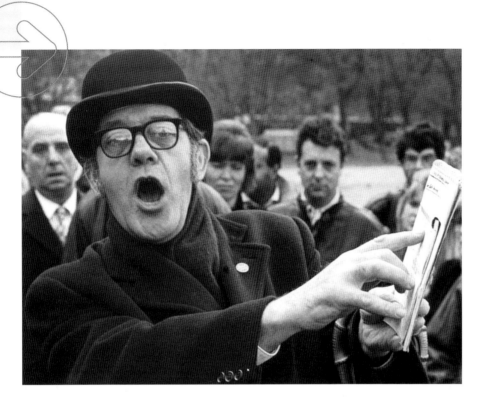

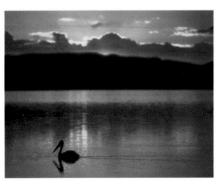

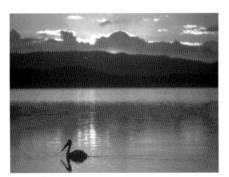

In this shot of London's Speakers' Corner, color would add nothing to the documentary approach.

With digital photography, the choice between color and black and white is no longer made when film is loaded. Now the creative photographer can experiment in the digital darkroom and determine which medium works best. It is as if, to paraphrase Ansel Adams, the score is the captured image, but the performer decides whether to play it black and white, color, or play it both ways.

Here, the original color slide works almost equally well in black and white.

Serious black and white film users view a scene through a lens that usually has a colored filter attached. The filter allows them to see the picture in monochrome so they can decide how to shoot the best possible black and white representation of the image.

There is nothing to stop the digital photographer from holding a yellow, orange, or red filter over the lens, even shooting the picture with the filter attached. But without destroying the possibility of outputting the picture in color, there are plenty of other ways to start thinking in monochrome.

There is no substitute for experience, but there are ways to gain it quickly. In Photoshop, convert some of your existing favorite color pictures to black and white, and decide which work best, and why. Often successful black and white images will be because of strong composition, patterns, textures, forms, and good light. The more images you convert to black and white, the more you will feel confident of assessing a new scene's potential.

Something else that can help you see in black and white is studying the work of favorite photographers or painters. Visit galleries or browse through collections and websites, examine magazine advertisements and books. Think about why a newspaper's front page or a CD cover may use a black and white picture. You will begin to recognize the sort of image that a particular photographer takes, or where the image is used in black and white.

Do not let color blind you. While a composition may be pleasing because of its colors, it may not work in monochrome if it lacks pattern, texture, form, and contrast. Conversely, when an image possesses such

You can improve your black and white photography by training yourself to see in monochrome. Try some of these techniques.

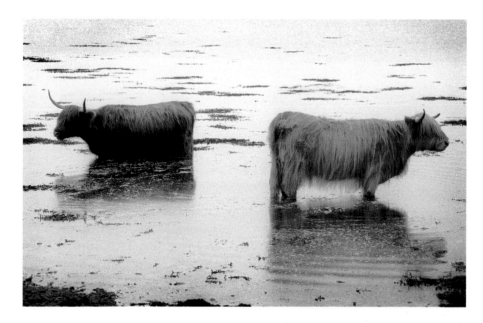

As a color picture, these Highland cattle would be over-whelmed by the filthy green water, but in black and white, their opposing directions stand out.

In this shot taken in southern Iceland, it was cold, dark, wet, and windy and the beach was (volcanic) black.

features, do not fail to photograph it simply because the colors are "wrong" or "poor," and especially not because the weather is bad. You may find that what has attracted you is something that will work well in monochrome.

Some film users find that shooting in black and white has a beneficial effect on their color photography. Without color's intoxicating attractiveness, they rely more on the esthetic, graphical qualities of composition, shape, and texture, and grow more sensitive to the quality and direction of light. As a result, their color images often work perfectly well in either medium, and they end up carrying a second camera to shoot monochrome versions too. Shooting in color but printing in black and white, the digital photographer gets the best of both worlds.

 TIP Hold a yellow or orange filter in front of a lens to see how a scene might appear in black and white. Even colored sunglasses can help.

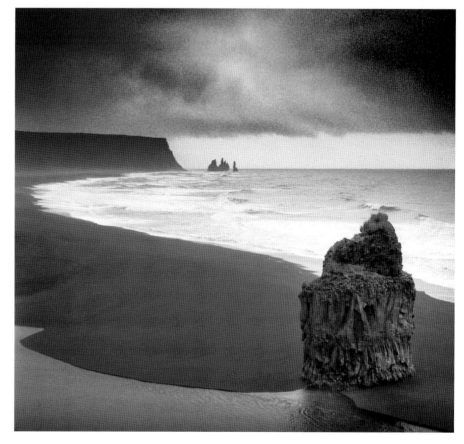

An eye for composition

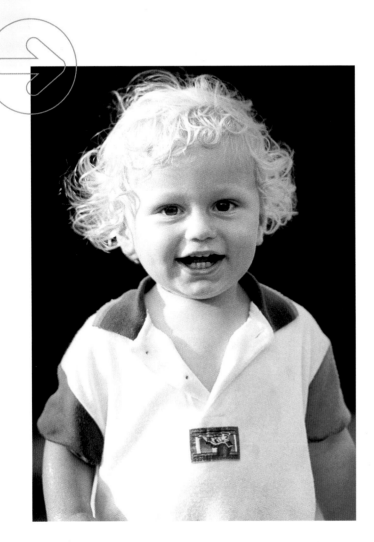

There is perhaps just one rule of composition: If it looks right, it is right. Yet there are so-called rules that can help you compose a picture. These can be applied when you compose the picture and release the shutter, and also later, on computer, when you have endless opportunities to frame and crop the picture before printing it.

Especially with autofocus cameras, it is too easy to shoot a picture with someone's face at the center of the viewfinder, right where the camera's focus rectangle is located. The subject looks small, with lots of space above the head. But if you watch the television news, for instance, the newsreader's eyes are much closer to the top of the screen, and this is because of the rule of thirds.

Also known as the "golden rule," this idea was current long before photography's invention. Mentally divide each side of the frame into thirds, and then make the image into a grid of nine areas. Then move the camera so that the subject lies at the intersection of the thirds. With the horizon, or another strong horizontal in the scene, compose the picture so that it lies on one of the two horizontal grid lines. Likewise, with a

For portraits, focus on the eyes, then recompose so the face is not right at the center of the frame. Also, while this little boy's curls were essential to this picture, often cropping off the top of the head concentrates the viewer's attention on the eyes.

Because of its importance in landscapes, the horizon—as well as the image's focal point—usually looks better off center. This photograph of a house in Tuscany was cropped in Photoshop to exclude a large expanse of the otherwise vast sky.

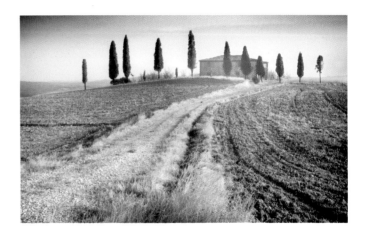

In much of northern England, fields are traditionally bounded by stone walls. Here, the wall acts as a lead-in line, drawing the eye into the picture and to the distant hilltop.

Sometimes, composition comes naturally: You just happen to be standing exactly in the right spot. At other times, it can help to use some of the old rules of composition.

strong vertical element, place it on one of the two vertical grid lines. If all else fails, and you can't see how else to compose a picture, try applying this rule.

Another valuable technique is known as the lead-in line. It relies on the way successful pictures often interest the viewer by moving the eye around the frame. One good way to do this is to use lead-in lines such as a road, river, trees, or some other shape. At times, they work simply graphically, as strong diagonals, but they can also point the viewer to the important feature of the image.

The war photographer Robert Capa once said, "If it's not good enough, you're not close enough," and there is a lot of truth to this idea. Filling the frame often improves a photograph. Move closer, zoom in, change lens, or crop the picture on computer. Look out for distractions in the image, and eliminate what is unnecessary.

The choice of portrait (vertical) or landscape (horizontal) format for a picture can also help fill the frame, but it can also suit particular scenes. Trees, tall buildings, individual people, and small groups are subjects that usually benefit from portrait format. Decide what is important in the scene, and be flexible.

Particularly in black and white photographs, a handy compositional rule is to avoid bright objects at the picture's edge. The eye will always be drawn to them, and they can be distracting. Equally, if deliberate, they may function as lead-in lines. In each case, it is best to check the edges of the viewfinder for bright objects and decide whether you need to recompose.

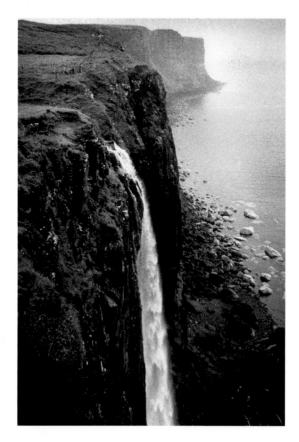

Portrait format allowed me to exclude a featureless stretch of ocean from this picture, and include as much as possible of this waterfall on the Isle of Skye. Note how the eye is drawn downward by the white of the falling water. Unfortunately, I didn't have a wider lens, and I couldn't lean any further out over the cliff, but the white close to the picture's edge is distracting, as if the bottom of the picture is missing.

In this photograph, the converging verticals were deliberately exaggerated by pointing the camera upward. Normally it is better to back away, change lens, zoom out, or switch from landscape to portrait format.

TIP See if your camera has an option to display a grid in the viewfinder. Some photographers find it useful to set this on all the time as it can really help get the horizon straight and avoid converging verticals.

Graphical building blocks

Carefully selected horizontals and verticals can be used to grab an interesting detail from an ordinary wall.

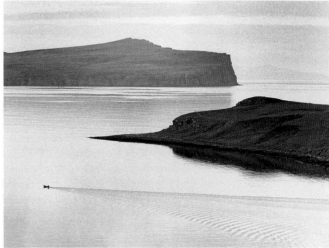

Here on the Isle of Skye, there seemed to be a triangle with the boat's wake at its base, and its left side formed by a lead-in line running up from the boat, straight between the headlands to the horizon.

Here, this Calabrian man had asked to be photographed by his motor scooter, but the mirror sparked this idea and I tried to shoot whenever his attention was distracted by a passing pair of female legs, nicely fulfilling a regional stereotype.

One attractive element of a black and white photograph can be the use of familiar shapes. These graphical building blocks can emphasize an overall structure, maybe frame parts of the image, and also lead the eye around the picture.

Some compositions work because subconsciously, the viewer recognizes that they are constructed from a variety of shapes, circles, triangles, and squares. Sometimes a shape alone, like the deep U of a glacial valley, is enough to make you admire a landscape and make the eye follow the slopes to whatever is on the valley floor. Conversely, an arch tends to draw the eye upward to show its decoration

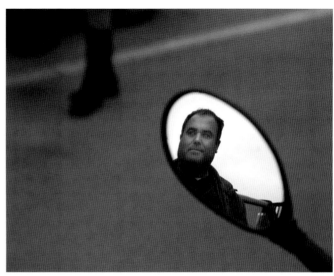

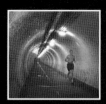
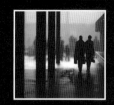

Often what is interesting in a picture is the recognition, subconscious or not, of underlying graphical shapes or of an allusion to a well-known scene, a painting, or iconic photograph.

or structure, and forms a frame for whatever lies inside or beyond.

Horizontal and vertical lines give strong structure to the photograph and, unless you deliberately want to draw attention to them, need to be perfectly square. Just before pressing the shutter, it's always worth checking that the horizon is flat. And some landscape photographers even use a spirit level that attaches to the camera's hot shoe. Similarly, if you point a camera upward to photograph a tall object, look out for converging verticals.

Diagonals can lead the viewer into the photograph, forming lead-in lines that point to the true subject of an image. They can also add a sense of drama to a photograph, and when they clash, it can portray chaos.

Another graphical element is lettering in its many forms. You can photograph signs or individual letters, or objects that just happen to form part of the alphabet. Indeed, one interesting project is to photograph the alphabet from found objects or in the urban or rural landscape. Such an exercise is sometimes what you need to push you past a creative block.

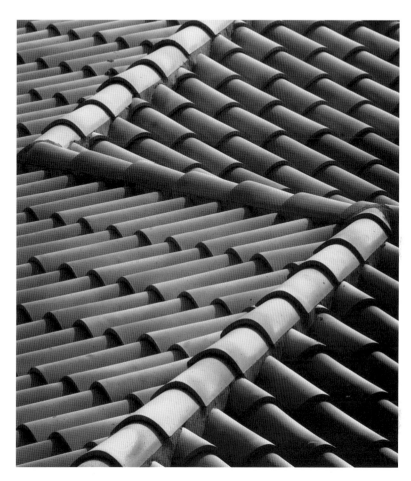

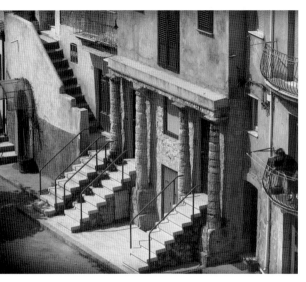

 From a rooftop vantage point, these steps in Calabria looked like an implausible, abstract construction. The old woman conveniently appeared at a window at the intersection of verticals and diagonals. There were some wires in view, but I removed them in Photoshop.

 This letter S was the roof of a harbor office.

Skinheads juxtaposed with this big head.

Pattern and symmetry

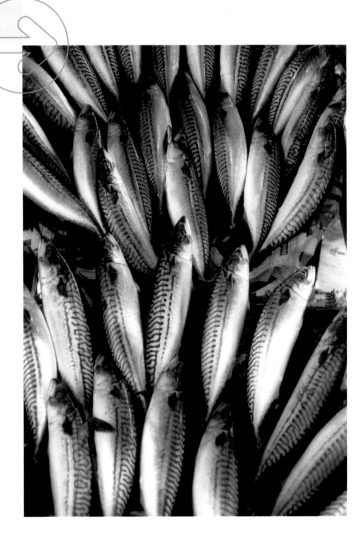

People make patterns usually just through being neat and tidy, seldom imagining the photographic opportunities they have created. Nature, too, fashions and erodes in beautiful ways. The black and white photographer can find these patterns and symmetries and use them to create abstracts that stand on their own, or that cleverly allude to their surroundings by including only the essential elements.

In black and white, we can admire the way these fish were displayed, unaware of the garish colors of the Turkish newspapers in the box.

Patterns are particularly suitable to black and white photography. After all, even if shot in color, repetition is emphasized by an essentially monochrome treatment. Colors can even be a distraction when seeking out patterns. Furthermore, many scenes are disfigured with modern clutter—security cameras or satellite dishes for instance—and in any case, the view may well have been photographed from every conceivable angle. The creative photographer can select what is important and portray it by zooming in on distinctive shapes.

Everyday locations often contain manufactured objects laid out in orderly style. A taxi parking lot, blocks of supermarket trolleys, or rows of rental bicycles can produce fascinating images. On a larger scale, look out for distinctive field layouts or for a hillside of tightly packed houses.

Forced back to my room in the Netherlands by rain, I was watching for a break in the weather when I took this. The tiles were a dull brick red, so any color shot would have been monochrome.

My shots of a Buddhist temple in Nara, Japan, seemed like any other tourist shots, but I spotted these slippers and felt I had come away with a distinctive image.

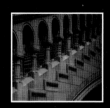

Patterns can become much more interesting when they are extracted from their surroundings, like this rippled landscape or stone staircase.

Sometimes, when the weather is uninspiring, seeking out patterns can be a great way to satisfy the urge to be out with the camera. At midday, when the light is usually strong and harsh, or on a day when the skies are gray and featureless, you can still find interesting details where others may not have imagined taking a picture. Even if you prefer to remain indoors, there are always opportunities—in the kitchen there is a cheese grater, two or three types of pasta, even the phone. With a macro lens, any of these could become a striking abstract.

Nature is especially full of essentially monochrome designs and formations. This may be in small details such as leaves and flowers, the markings of a single animal, the undulations in the shore left by the retreat of the tide. But it can also be in the repetition of trees, herds, and flocks, sand dunes and hills. You may have observed something many times before and be struggling for inspiration, but it may contain patterns that you have overlooked that can suddenly inspire a burst of creativity.

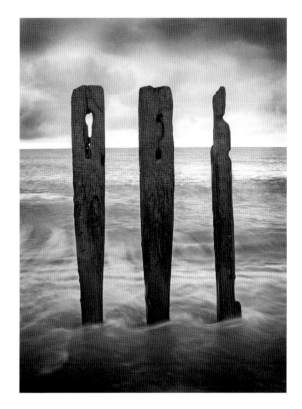

Look out for other objects that are laid out by man for more utilitarian purposes. It is easy to dismiss them as damaged, or as a blot on the landscape, but for the photographer, nature can render them more interesting. These groynes, sea defenses, on the south coast of England, have a symmetrical, sculptural quality.

These hexagonal columns hang off the rock face behind Svartifoss, in Iceland. The black *volcanic rock meant I had to take an exposure reading from some grass off frame.*

Rome's St. Peter's Square was hot and crowded and is the subject of countless standard views. But the colonnade was cool, and the shafts of light reduced the columns to this interesting pattern.

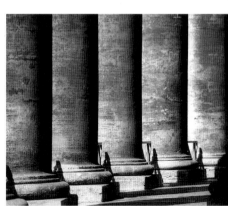

TIP If you like abstracts, take a look at Photoshop's Pattern Stamp tool. This allows you to sample an object and use it as a repeating pattern in your picture.

Another view around St. Peter's Square shows how pattern can be combined with a focal point.

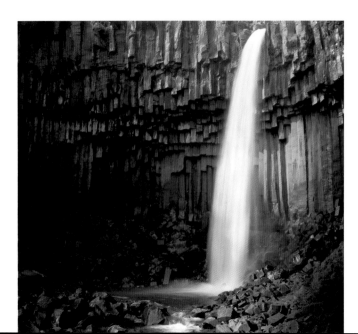

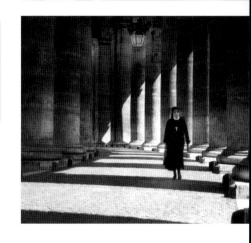

Viewpoint and perspective

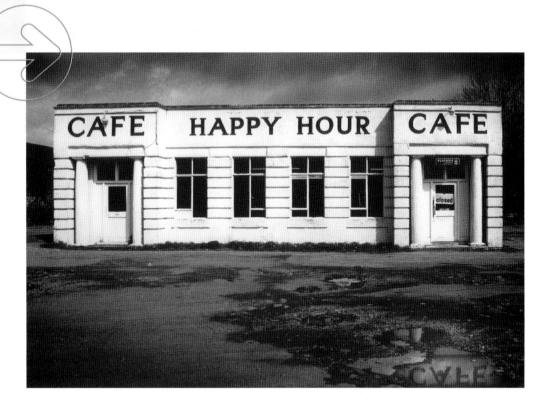

To fit this English roadside truck stop into the frame, I had to step back, but the wide-angle lens included a lot of featureless gravel until I moved to the right and was able to use a muddy pool to include a reflection. Photoshop's Burn tool was used to make the left foreground less obvious.

TIP Try photographing the same scene with each of your lenses, or with a zoom lens and at different focal lengths. This will force you to move, recompose, and find a new perspective of the subject.

A wide-angle lens can convey a sense of a scene's sheer scale and depth, but it can also include a lot of foreground. Though your attention may be on the landscape or on a distant focal point, check the viewfinder and see if something can fill an empty foreground, act as a lead-in line, or add interest to that part of the picture. Equally, look out for distractions. If you cannot avoid empty foregrounds, try gently burning in that part of the image, making it darker and less noticeable.

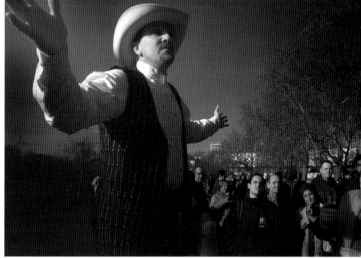

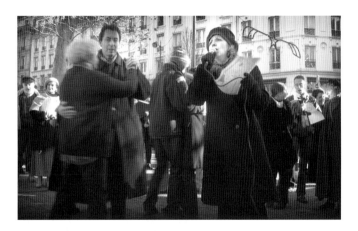

Using a wide-angle lens and sitting in the street gives the impression of being literally in the midst of this Sunday-morning neighborhood dance in Rue Mouffetard, Paris.

Here at Speakers' Corner, someone heckles the self-proclaimed "Cowboy for Jesus". The wide angle gives the impression of being there. Also, note how the low viewpoint makes the cowboy look more important.

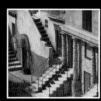

Moving around, or swapping lenses, can drastically alter the balance between different areas of the frame.

Viewpoint and perspective

A wide-angle lens is also great for giving the impression of being right in the middle of events. It also has a lot of depth of field, and this can be great in a crowd when you have little time to compose and focus, and sometimes need to shoot blind, candid shots. On the other hand, a close wide-angle shot can be very unflattering to people, exaggerating the parts of the face closest to the lens.

A longer lens will have a narrower angle of view and is a much better choice for a portrait than a wide-angle lens. With a more compressed perspective and a smaller depth of field, the photographer can decide whether to have only the subject in focus or to make distant objects appear closer to it.

Moving around and finding higher or lower viewpoints are reliable ways to improve a photograph. These techniques can often reveal a new perspective on a subject, and can be equally useful to deal with irrelevant parts of a scene, sometimes by shooting around them or

cropping them out of the frame, but also by hiding them behind other objects—much easier than doing it in Photoshop later.

A low viewpoint can be particularly helpful when photographing children and animals. Anything small will appear better proportioned

if the photographer gets down to the same level. When viewed later on computer or as a print, it will not appear as though you were looming over them. But a major reason for adopting a low viewpoint is also to put children and animals at their ease.

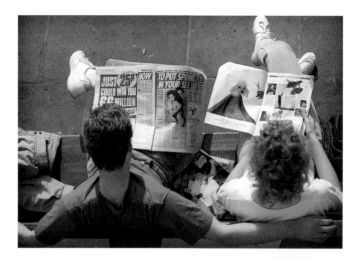

In London's Trafalgar Square, this couple appeared ordinary when I walked past. But when I looked down directly over a wall, they were reading the strangest combination of newspapers.

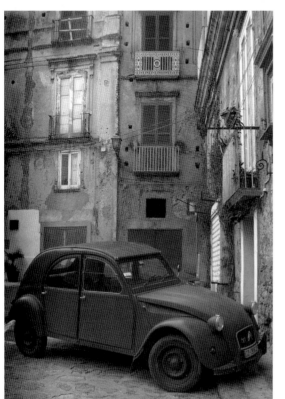

Here, the low viewpoint served to hide more modern cars in this Italian square.

Kneeling down in an alley in southern Italy and using the maximum focal length of a 70–210mm lens was the only way to avoid frightening these cats. A shutter speed of 1/500 second prevented camera shake, and the resulting f5.6 aperture was still small enough to show the other cat's shape. While I was not conscious of it when shooting, this photograph was also helped by the shadow forming a lead-in line.

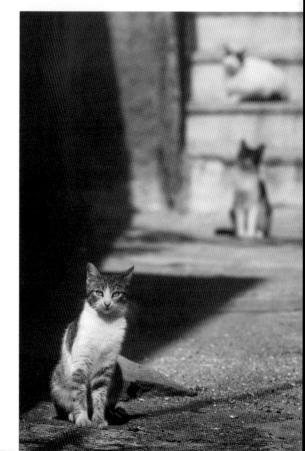

Framing

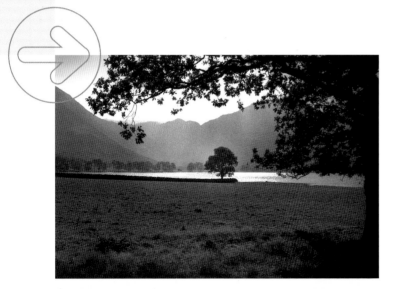

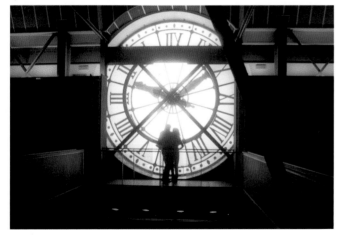

So, apart from balancing the picture visually, framing keeps the subject in its context, but without the visual overload and clutter of the complete scene. Sometimes it's almost a narrative, too, as if the photographer is allowing the viewer a sneaky view. It's part of the art not to make this too corny or contrived.

You can discover frames simply by walking around your subject and observing its surroundings, but photographers have long ago learned to create images artificially. Skilled darkroom workers often have favorite negatives with frames—masking off areas as they print the two negatives onto the same sheet of printing paper. With digital photography, this is much easier and can quickly become quite addictive.

 Look for photographs where the frame is formed naturally—an arch, tree branches. Here, the scene was an

Sometimes a scene just presents itself, but your feet are an important part of your camera gear. Walk around the subject, look behind you, and see if stepping behind something actually improves the picture.

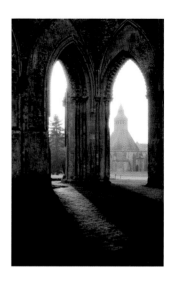

ugly suburban railway line, but the footbridge's structure formed attractive frames when people and their dogs crossed the bridge.

Often, without thinking about it, photographers often frame a subject, sometimes using the branches of a tree to draw attention to their subject. Or, an architectural feature might isolate a subject. Equally, the subject might only become attractive when placed within a frame, such as in this picture of a couple standing in front of a clock, or this image of a tree framed by another tree.

Framing is a technique of composition that dates back long before the era of photography, certainly back to the Renaissance and probably long before.

TIP When dropping in another image, be careful about the direction of the light. Here the arch was flipped horizontally (*Edit > Transform > Flip Horizontal*).

Consider whether you can take advantage of things that might threaten to spoil the picture. Here, I couldn't fully see the singer because the guitarist kept swinging in front of me. But then I realized his arm and the guitar strap could form part of the composition.

For the digital darkroom, build up a library of items on your computer that you can use to frame other photographs. Carefully select the inside of the frame in Photoshop and cut it out. Then it's often a quick job to drop a new photograph behind the frame.

Isolating details

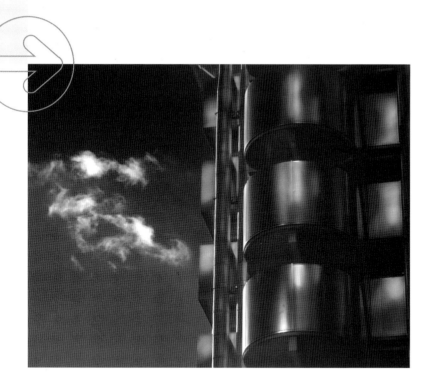

Anyone who has ever seen London's Lloyds building will recognize this detail.

Sometimes it is impossible to find a good view of something you want to photograph. A tall building may not fit in the frame, you may not have a lens wide enough, viewpoints may be obstructed, or the subject may lie in unattractive or distracting surroundings. But even when the view is clear and it is possible to include everything, sometimes just a detail is sufficient to make a good picture. Such problems can easily be used to the photographer's advantage. Try moving in closer. Apart from eliminating many obstructions or distractions, you can fill the frame with just the part of the scene that strikes you as important. A zoom lens is not just for zooming in on people in crowds or on a sports field; it can also pick out interesting parts of landscapes and buildings. Deciding to include details rather than the whole scene is a great way to force yourself to think creatively.

Another way to isolate details is to use the effect of depth of field. Identify carefully what you want to focus on, and then set a wide aperture to throw the rest of the frame out of focus. This is a great opportunity to experiment with differential focus, where the frame contains blurred objects both in front of and behind the subject. In these circumstances, you can use a macro lens. They are not simply useful for still-life and nature photography; they can let you get really close and exploit the lens's short depth of field.

With well-known places, it is easy to be awestruck and include the whole scene in the frame. The same view will be on every postcard and on everybody else's photograph of the scene. It takes more thought to portray the whole using just a detail, but it is much more satisfying, especially if no one else had the imagination to do so.

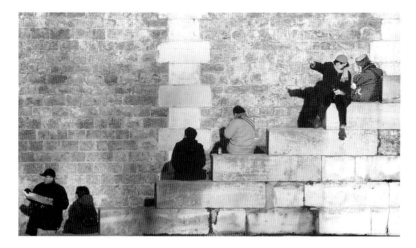

Details may lie within details. I used a zoom lens to cut this Paris scene *down to the steps and the man's enthusiastic gestures and deerstalker hat.*

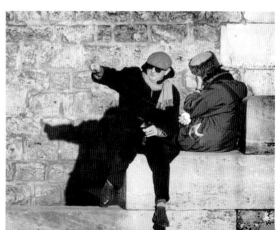

Use different techniques to isolate details, depending on the image you're shooting. Differential focus is one method, careful cropping is another.

While it is always going to be better to get it right in the camera, there are further opportunities to select the important detail in the picture when you are working on it on the computer. Occasionally, you may spot something interesting that you never noticed through the viewfinder. While enlarging part of the image will reduce print quality, cropping the picture may well result in an image with much greater impact. You could even print zoomed-out and detail versions of the photograph and display them side by side. Also, if you want to try to replicate narrow depth of field, take a look at Photoshop CS's *Lens Blur* filter. It will never be the same as using the lens aperture, but the image may still be strong.

Anyone can take a snapshot of a beautiful scene, but the creative photographer gives a little more thought to capturing its essence.

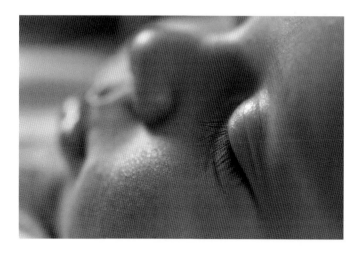

Seeing a friend's new baby for the first time seemed like a good chance to try out a new macro lens. Only the eyelashes are in focus.

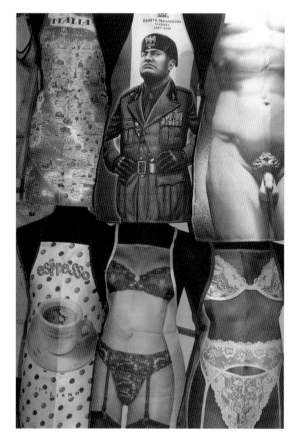

TIP To force yourself to look for details, try doing a series of photographs on a certain theme—ancient and modern, little and large, and so on.

The front of the Museum of Mankind in Paris was so bland that I don't remember its appearance. But I found this bizarre frieze at the back of the building.

The intercom on this old building shows how some cultures casually combine their past and present.

Keep your eyes open at all times. Even tacky tourist shops, such as this T-shirt shop in southern Italy, can contain ironic combinations of detail.

The quality of light

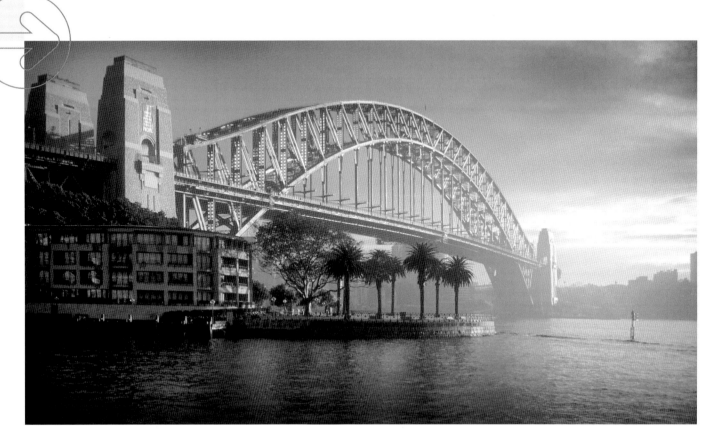

Photographers, with practice, develop a fine appreciation of the quality of light. They notice its clarity or haziness, its color, warmth, or coldness, and often learn much more about the weather or other atmospheric conditions than they ever imagined. Reading the light is important for all types of photography, but as we initially see images in color, it is important to understand some of black and white's special requirements and advantages.

Mornings and evenings often provide the best light for photographers. When the sun is low in the sky and passes through more of the atmosphere, it cuts out light from the blue wavelengths. So the light is warmer, especially good for color photography, and shadows are longer and at more interesting angles, often revealing textures in surfaces. It also changes more rapidly and a subject may suddenly fall into shadow, so think ahead about how the light will change, and work quickly. Each image needs to be converted to black and white individually, but remember morning and

Fog can clear in the most beautiful way. In such conditions, avoid using a polarizer, which would reduce the shimmering brightness.

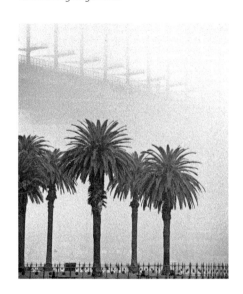

Taken earlier the same morning. At times a layer of thick fog completely obscured Sydney Harbour Bridge but left the palm trees distinct.

We all know much more about the quality of light and could see a photograph and recognize the season or the time of day.

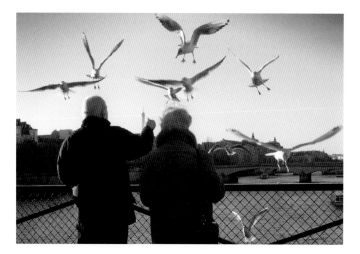

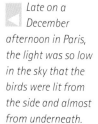

Late on a December afternoon in Paris, the light was so low in the sky that the birds were lit from the side and almost from underneath.

On a bright morning in southern Italy, the light reflected off nearby buildings gently flattered the subject.

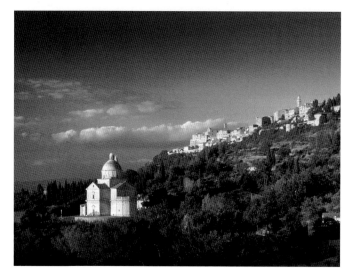

During the day I had driven past this church on the western side of Montepulciano in Tuscany, and I returned to it at sunset. Orchards in the foreground were quickly falling into shadow, but the strong evening light isolated the church and picked out the town and the clouds.

TIP When traveling, check the local paper for sunrise and sunset times.

evening shots probably contain more red, and this will influence how you use more advanced methods based on filtering the RGB channels.

Midday light is often more blue, and shadows are strong, vertical, and harsh. Resulting photographs are often flat and unflattering—people will screw up their eyes to shield them from the sun. None of this means you should avoid taking portraits, just that you might reposition your subject and see if you can use strong light bouncing off the ground to supply some fill-in lighting. If the light is hazy, consider putting a polarizing filter on the

lens, as it can cut down haze and reflections. When converting a midday picture to black and white, you may have to use more of the red channel to deal with the blueness of the light. Also increase the red channel filtration to reduce haziness, and the blue channel to exaggerate it.

Flat light can make it easier to get good pictures of people. Of course it can be too drab, but the eyes are more open, and the lower contrast means that there is less chance of blown highlights. Afterward, when you work on the picture on computer, you can always

control how much contrast to introduce. As an extreme example, a key to wedding photography is to show detail in the bride's white dress, and this is often much more difficult in sunlight. If you blow the highlights in camera, you can't get them back when working on your picture on computer.

Diffused light is often most obvious in the morning, and fog or mist can often produce attractive images, especially if you shoot into the light as the sun starts to burn through. But luckily, even a brownish pollution haze can work in black and white.

Light, shape, and form

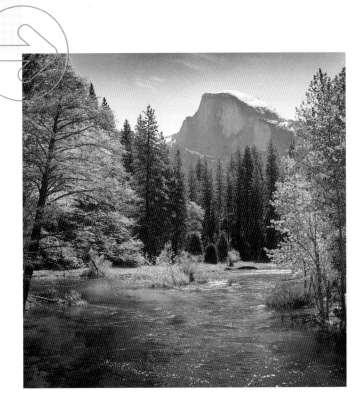

A morning photograph of Yosemite's Half Dome shows the face of the mountain in shadow but sun glinting off the snow and water. The overall effect is of springlike brightness and depth.

Shot from the same location a few hours later and with the sun behind me, the rock face stands out, but the overall image is much flatter.

A camera captures reflected light. If the light source is directly behind the camera, reflections bounce back directly off the subject and give an idea of its shape but not so much of its forms, scale, and dimensions. But if lit from behind or from the side, the camera captures more light reflected off the subject's angles. There are more, brighter highlights and fewer shadow tones, contrast is higher, and the subject's shape and form become more distinct.

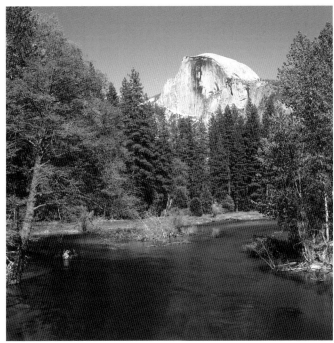

When the light comes from behind the camera, a scene has less contrast, lighter-colored areas stand out, and shadows are filled with light and contain visible detail. But the photograph's overall impact is often drab and flat. However, when the camera is pointing into the light, edges and shadows become much more distinct. In a landscape, for example, the sun may shine through leaves, making them stand out, showing the different types of trees and silhouetting trunks and branches. Light also bounces brightly off water and other surfaces. This results in an image with much more of a

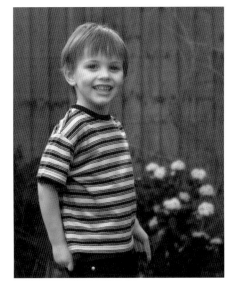

Shooting into the light: The shape of the boy's head is outlined by soft light being further diffused by his fine hair.

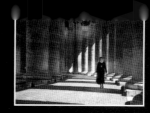

Our impression of shape and form is more than the differences we see between a subject's light and shade. It also comes from the angle of the light and the subject's edge.

sense of depth. Also consider the quality of light. Strong, raking light is often better able to show the form of angular structures, but diffused light can reveal more subtle forms in faces and other softly rounded objects.

As well as the angle and quality of light, the physical composition of a subject's edges is important for conveying its shape. This is especially important in outdoor portraits. With the sun in the subject's face, and less contrast, the shape of the head is not clearly defined against a background lit by the same light. But with the sun behind the subject, the light is diffused by the many individual hairs and forms an attractive fringe that brings out the shape we expect to see in a portrait. Objects with multiple angles are great for exploring shape and form, especially when they are shiny or wet. Very bright specular (mirror-like) highlights can bounce off many angles, and even on a particularly drab day, shapes with such surfaces can stand out.

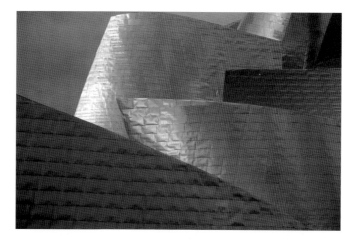

Even on an overcast day, light shines off the many angles of the metallic surfaces of the Bilbao Guggenheim, revealing its complex shape.

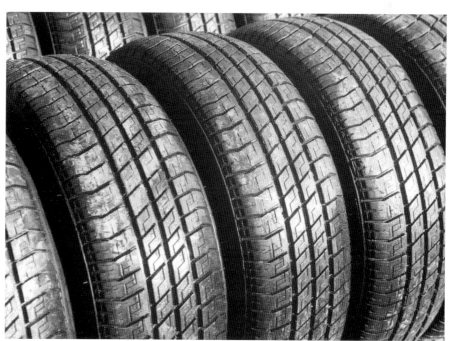

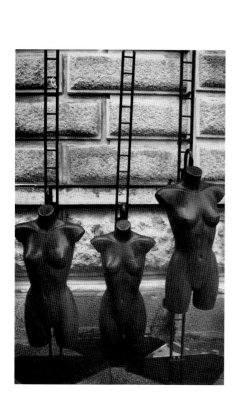

Heavy rain ruined the day for the traders at this market, but the dummies' wet edges and curves caught my attention.

These tires, from a race barrier in Monaco, again show how angular light reveals shape and texture. Light bounces off the

painted surfaces but is absorbed in the tread of the tires. Shooting this a few steps to the right would have destroyed this effect.

Light, tone, and contrast

A black and white photograph is not just a grayscale version of the color world, as if the colors had simply been discarded. While black and white film users have always known how using colored lens filters can control an image's tone and contrast, photographers without such experience are often surprised by the subtle and varied tonal balance that can be achieved. Digital photographers can employ similar controls to convey their special interpretation of a scene, get the most attractive balance of tone and contrast, and convince the viewer that these tones represent reality.

On this page are four photographs of a bearded man. Each of the monochrome versions could be presented as realistic, even the pale-skinned man in the dark sweater and the dark-skinned man with a lighter-colored sweater. Without the color original, the viewer might prefer one picture's appearance, but would not know which photograph might be closer to the truth. The man might originate from a gray-skied country, or from somewhere sunnier and warmer. There is no digital trickery at work: The only difference between the monochrome versions is how the image's color channels were filtered to make the image black and white.

While this is an extreme example of how tones completely change the photograph's interpretation, the same principle applies to any picture. Harsh contrast, with lots of dark and bright tones and few midtones, can emphasize bad weather, while a softer approach is often more suitable for a portrait of a child. A harder treatment may give an image a journalistic feel, for example, while a softer approach may suggest a quieter moment or an earlier era of photography. It is a subjective decision that lets the creative black and white photographer express his or her own personal style and interpretation.

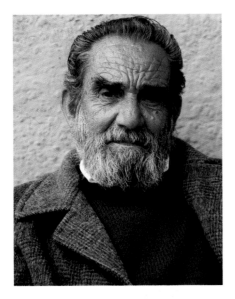

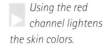
This man was sitting in the shade outside a café in southern Italy.

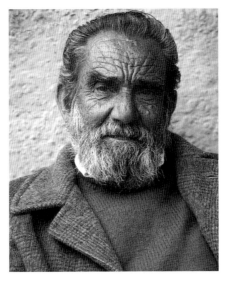

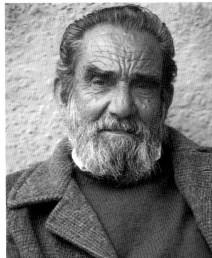
Using the blue channel darkens the man's skin.

Using the red channel lightens the skin colors.

A mixture of red, blue, and green channels produces the most accurate black and white conversion.

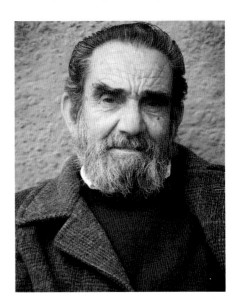

The initial appeal of this piece of wood was the warm light and vibrant green. Nevertheless, the strong shapes and variations in tone make it work in monochrome, too.

Much of this fine-tuning of tone and contrast has always been achieved long after releasing the shutter. As well as using colored lens filters, the film user carefully selects paper grades and employs a range of darkroom skills. The digital black and white photographer has many tools, above all Photoshop's *Levels* and *Curves*. As you work on an image, it is important to evaluate the changes carefully on the monitor. Usually, while the overall contrast may vary, aim to achieve some near-black shadows, detail in the brightest areas, and a smooth gradation of intermediate tones. A properly calibrated monitor can help greatly, but also keep a close eye on Photoshop's histogram, which charts the number of pixels of each brightness value. This can often show where the image does not contain true highlights or shadow tones, or where the highlights are burned out or shadows blocked up. Photoshop's *Levels* tool can sometimes help you fix these problems. It also uses a histogram, so learning to read this information is vital to fine-tuning tone and contrast.

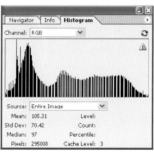

This image has a full range of tone with midtones appearing on the histogram like a plateau, but the left and right edges sloping down to black and white.

But this version, without any true blacks or whites, lacks impact. This is visible in the histogram, where the slopes never reach the left or right extremes.

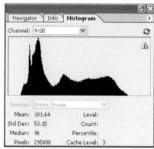

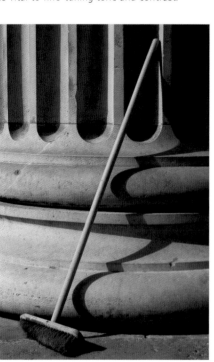

 An almost-monochrome image usually works in black and white because it initially draws attention by its forms, tones, and contrast.

You can make photographs with no midtones at all. This was done by adding a Threshold adjustment layer in Photoshop.

TIP If you want the best-quality black and white images, never use black and white modes on your digital camera.

High key

Most black and white photographers develop a style, part of which is a typical tonal palette or balance. A preference for dark or light images may be the result of an esthetic sensibility; it may reflect the weather or even sometimes an outlook on life. High key images contain little shadow, some midtones, and a lot of highlights. Such images often have an elegant, more graphical quality.

Sitting in the shade outside a café in Calabria, this young man wore beige and was quite pale skinned, and his hair and eyes were the only true black in the scene. The digital image was converted to black and white mainly using its red channel because it kept the man's skin tones very soft and was more suitable to the high key approach.

A subject may be instantly recognizable as suitable for a high key treatment. There may be relatively few shadow tones in a landscape early in the morning, or where it is strongly backlit or in bright sunlight. The subject may be composed mainly of lighter tones, such as snow or frost in winter, spring foliage, or a bride in her wedding dress. In other cases a high key treatment may not be so obvious, but the scene may be framed or cropped to exclude areas of shadow. Such a selection may then emphasize certain qualities such as brilliance, softness, delicacy, youth. Also, with a high key picture there is a difference in how the viewer examines it, the eye not being drawn into the highlights but jumping between the few darker details that stand out.

When photographing a high key subject, there is always a risk that the predominance of bright tones will cause the camera to underexpose. In this event, the highlights at least contain detail and can be lifted when you work on the image in Photoshop. But it is always better to get the right image in the camera by overexposing a little, maybe just a

High key treatment often suits brilliant light, such as in this spring morning landscape from Naurod in Germany.

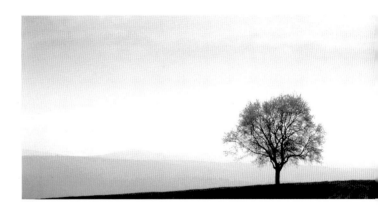

A high key photograph is one where there are mainly light tones and can produce a softer, more youthful image.

fraction of a stop, not so much that highlights are burned out. Make sure that you review the results on the camera's LCD screen.

When working on a high key image in Photoshop, the *Curves* adjustment layer is particularly helpful, especially if the picture is slightly underexposed. Judge each image individually, but a good starting point is to drag the curve into a letter S. Such a curve darkens the shadows and both lifts the highlights and brings more gradations of tone into the brighter parts of the image. If you use them gently, *Curves* offer very precise control and therefore are ideally suited to revealing the more subtle detail in the high key image.

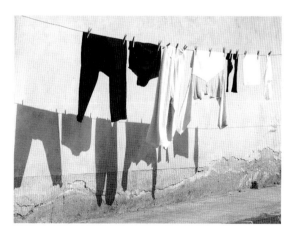

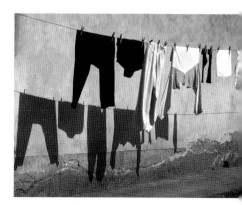

This washing line was in full midday sun. A high key image was produced by framing the scene to exclude the surroundings and a bemused Italian housewife. The scene was bright but in mixed tones and the camera's calculated exposure is perfect.

The same image can easily have high key and low key versions. By darkening midtones and highlights with Photoshop's Curves, this looks more like a late-afternoon shot than one at the brightest point of the day.

In Photoshop, an S curve darkens the shadows and lifts the highlights. Here the S is gentle, and the curve passes through the center, indicating that mid-grays will be unchanged.

TIP For high key images, be careful with any "edge burning." This would hold the image in but a high key image is characterized by its great luminosity.

The Threshold filter, with a bit of masking, can also produce high key graphics like this close-up view of Speakers' Corner.

Another gently high key treatment shows an early-morning discussion while overlooking the Mediterranean.

Low key

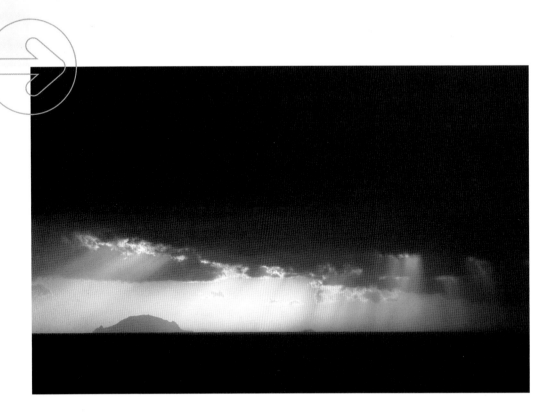

Dramatic sunset light can change in moments. Taken with a zoom lens (to get as close as possible), this picture shows the Eolie Islands after a tremendous storm. Most shots were checked on the LCD, with its option set to the blown highlights warning. The issue was to capture detail in the backlit clouds over the horizon. Though there was some detail under the cloud cover, this was not critical.

Some photographers' palettes are dominated by dark tones. This might reflect a liking for wild, bleak landscapes and heavy skies, but it can also be a softer and much more subdued approach to photography. Low key images rely on having many shadow tones and dark midtones, but few highlights. This makes them great for expressing somber moods, but judgment needs to be used to avoid making the image look too heavy and try to include a little brighter detail.

Low key scenes may at first appear too drab to photograph. Bad weather or a dark interior may seem to ruin the scene, but there is no need to be deterred if there is something of interest. In black and white, there is no need for vibrant colors, and the digital photographer can always increase the sensor sensitivity to deal with weak light.

Many low key scenes comprise mainly shadow tones but also contain areas of great brightness. While the photographer may want to convey the overwhelming gloom, these highlights will usually become the focal point of the image and need to be properly exposed, usually even if that means underexposing and losing some shadow detail. With difficult scenes, check exposures on the LCD, bracket exposures, and review the versions later on a computer monitor, where you will be better able to decide which is best. Alternatively, if you are using a tripod, make separate exposures for the shadows and highlights and merge the shots on computer.

When working on the picture in Photoshop, the low key mood can be enhanced by making the image darker with *Levels*, or by lowering

There was little tonal contrast, and only a small, dim, brighter area in this scene. In

Photoshop, the digital image was further darkened by using a Curves adjustment layer.

 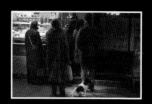

A low key photograph is one in which dark tones dominate the image and produce a moody effect.

This chef stood in the door of his restaurant in Tropea, in southern Italy. It was so dark that ISO 1600 was needed, and the glint in his eye came from moving him a fraction forward into the dimly lit alley.

TIP When printing low key images, ensure you use good-enough quality paper to avoid ink saturation (*see page 128*).

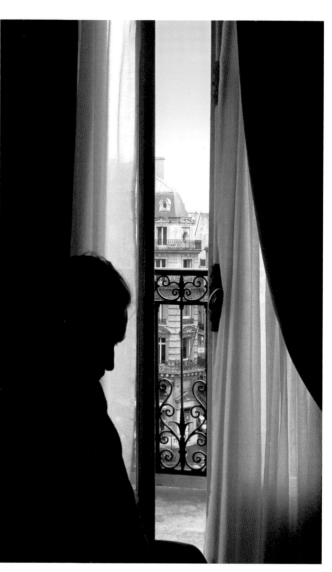

the shadow tones with *Curves* adjustment layers. This can easily be overdone and appear too heavy and unnatural, so it can be better to work more on specific areas. For example, a landscape's mood is often subdued by darkening the sky. Another technique is to add a little bit more edge burning than might be needed to hold the image together. Consider adding a tone, too: A cold sepia or deep blue can really create atmosphere.

A strong tone can emphasize a low key mood. This shot was taken on a relentlessly rainy weekend in Paris.

TIP When checking your camera's screen, remember that these displays are not as good with dark shades as most printers are.

Light and texture

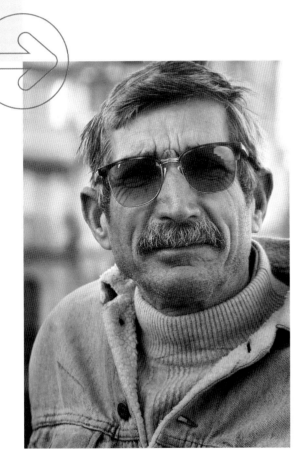

Textures may be interesting photographic subjects in themselves, but they can also add a touch of realism to any subject because they convey how it feels. They give the viewer another sense through which to interpret the picture, suggesting that an object is smooth or rough to the touch, wet or dry, firm or slippery, finely grained or soft, like fur. Yet the existence of textures in a subject does not mean they will be visible in a two-dimensional image. It is light, especially its direction, that helps the photographer to reveal these tactile qualities.

Diffuse morning light shows the detail of this man's soft sweater and his moustache, giving another level of realism to this picture.

You can find textures everywhere and use them to enhance almost any type of picture. With people, showing the wrinkles in an old man's face adds to the picture's impression of youth, age, or character. In nature, show the delicacy of birds' feathers. Look indoors or outdoors: The home and garden may contain a surprising wealth of textures that can be picked out. Try using a texture on its own, possibly as an abstract, or use it to add detail to another subject. Combine it with showing an object's shape, or use it with other textures, sandy against silky, shiny against matte.

There are some surfaces that reflect light at many angles, but in general, light from directly behind the camera will make the subject appear more two-dimensional, and textures will be less obvious. But when the light is raked or angled across the subject, its texture is revealed by the small shadows created in the surface's bumps, scratches, and other undulations. When the texture is more subtle, such as in a young child's soft skin, the angle

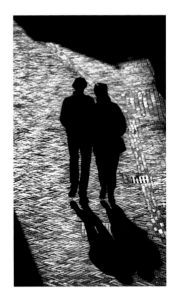

Texture can be seen in the landscape. This alley was backlit by strong evening sun, and the herringbone pattern of the paving bricks shows.

The strong winter-afternoon light is at a low angle, emphasizing the smooth shapes of the stones.

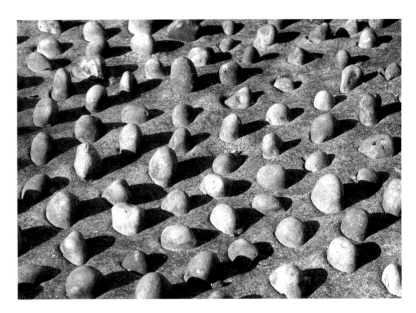

The angle of your light source, be it the sun or carefully positioned studio lights, can make a dramatic difference to your finished photograph.

Still-life subjects are great for using or portraying texture, but lit with strong light from the front, this pineapple appears flat.

With a still life, you can move the light source if you use off-camera flash or, as in this case, a powerful incandescent "Photoflood" light. Light from the side brings out the sharpness in the pineapple's leaves.

of light needs to be more acute than in a rough surface, such as tree bark.

While the direction of light is most important, the quality of light should also be considered. Where a surface is fine, such as in a soft wool sweater, a diffuse light usually creates bright highlights and strong shadows that overwhelm the details. A coarse or glossy surface usually benefits from stronger light.

Combining texture and pattern often works well. Here, an orange rubber mat was found on the foreshore.

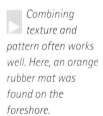

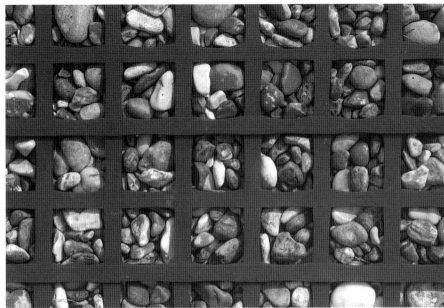

Shadows

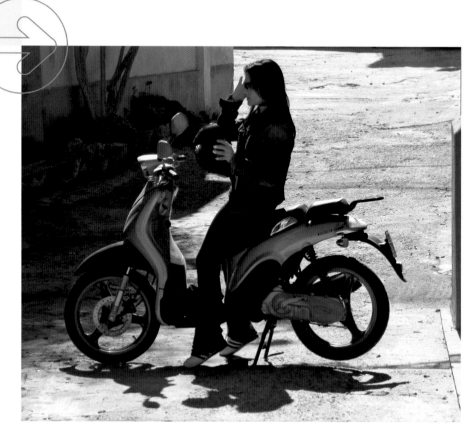

This Italian girl was checking her appearance in the mirror. Buildings were on either side, and there was a parked car to the top right: Their shadows frame the picture. It was midday, too, so the sun was high, but the shadow of the girl and scooter was strong and recognizable. When you notice shadows like these, try to include them fully.

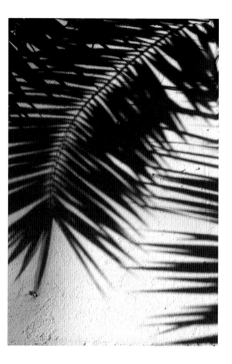

Looking through the viewfinder and concentrating on the main subject, the photographer can easily overlook shadows. If there is light, there will be shadows, and they are particularly important for black and white photography. At times they may be ugly or distracting and need to be avoided. At others, they can be employed as part of the composition, or as a subject in themselves.

Shadows are yet another feature to try keep in mind in the excitement of composing a photograph. Carelessly included shadows can really stand out and detract from a picture. Look out for strong shadows across a face, and consider positioning the subject to avoid them. With a landscape, you can often wait for the sun to move, or for a break in the clouds. Light quality can also make a big difference: Diffused light will make shadows less obvious, while strong light can make them dominate

Found in an ordinary alley in a small Italian town, this palm tree didn't need to be included in the picture: The shadow itself was sufficient.

On their own, these shadows look like graffiti but their origin is explained by the inclusion of a corner of the window and its bars, juxtaposed with the paint line following the rule of thirds.

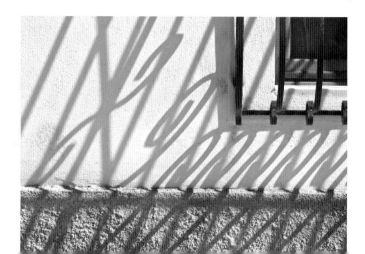

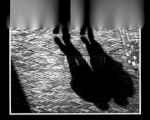
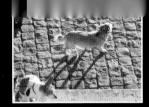

Using shadows in black and white photography is an excellent way to balance a composition. Look out for their strength and direction whenever you're taking photographs.

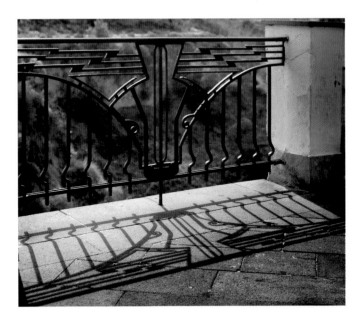

It can often be a good idea to examine the scene with both eyes, not just through the viewfinder. Initially, the camera was at a right angle to these Art Deco railings, and the composition was cropped very tightly. It was only when admiring the view beyond that I noticed the backlit shadows.

the picture. The color of shadows varies too—being more blue at midday or at altitude—and this may affect how you use channels to fine-tune the conversion of an image to black and white.

It is possible to use shadows in many ways. They can give shape, depth, and form to a picture. They can also balance a composition, making a good base or grounding for the image, pushing the eye up toward its subject. With black and white, bright objects and areas can be distracting, particularly near the picture's edge, while shadows around the edge can draw attention to the subject, even frame it. Distinctive shadows may themselves be the photograph's focal point, with their origin being cropped out entirely, or being included only to let the viewer decipher their context.

Sometimes the subject can be in shadow and too dark because the background is so bright. Using flash can fill in these shadows, but this may produce an artificial effect. In such cases, Photoshop CS has a great new feature that may quickly balance the image, under *Image > Adjustments > Shadow/ Highlight*. This adjustment lightens shadows and darkens highlights, depending on neighboring pixels.

TIP
Shadows move predictably during the day, and it is always worth returning to a subject when the light may be coming from a better direction.

This picture of a fish seller shows the effect of Photoshop CS's new Shadow/Highlights image adjustment. In the "before" version, his face is drab, but his coat and other

highlights looked fine, so only the default adjustment was applied. The shadows are noticeably lifted, and the coat and background are unaffected.

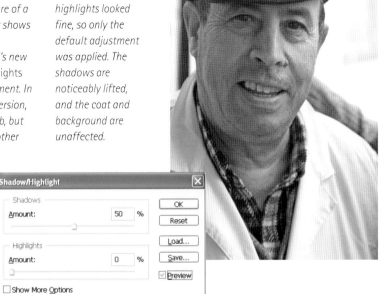

Shadow/Highlight

Shadows
Amount: 50 %

Highlights
Amount: 0 %

OK
Reset
Load...
Save...
☑ Preview

☐ Show More Options

Contre jour and silhouettes

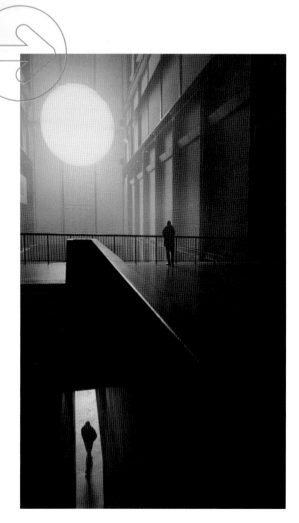

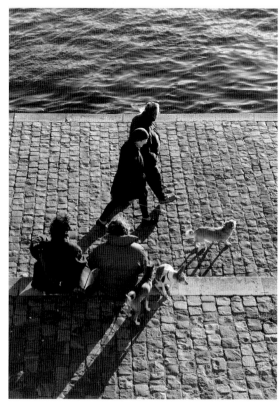

This image is both backlit and silhouetted.

On a December evening by the Seine in Paris, I used a lens hood to reduce the risk of lens flare from sunlight, and also from reflections off the water.

Backlit, or contre jour, shots and silhouettes are among the more dramatic types of photographs and are especially suitable for black and white because of their starkly graphic nature. Shooting into the light can produce images with depth, attractive highlight fringes, and strong contrast. A silhouette is a black outline, but its background is properly exposed and puts the subject in its context.

Backlit shots mean completely ignoring the old adage to keep the light behind you, but that was never very good advice anyway. There is, however, an increased risk of flare. A slight adjustment of camera angle can make the difference, so check the viewfinder just before releasing the shutter, and use a lens hood. Sometimes it is necessary to overexpose a little for a backlit shot.

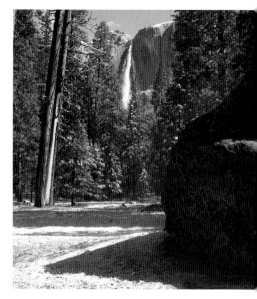

Backlit conditions may fool the camera meter. In this shot of Yosemite, snow added to the problem. Take an exposure reading off average gray parts of the scene, maybe switching to spot mode.

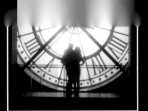

Backlit and silhouetted images work well in black and white, and, thanks to digital editing, it's possible to perfect the light level later in the process, or even exaggerate the effect on your subject.

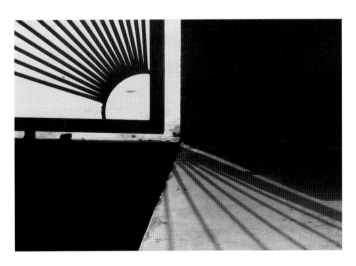

A wall and cast-iron barrier were backlit by strong morning sun.

In some ways, a silhouette can be very easy to photograph. If most of the scene is bright, the camera's program will tend to underexpose, leaving the subject as a dark silhouette. Alternatively, set the exposure manually after taking an exposure reading from the bright part of the scene. As a last resort, there is the digital solution: Some contre jour pictures can be made into silhouettes by darkening them in Photoshop using the *Levels* or *Curves* tools, but be wary of the overall look of your shot.

The metered exposure of this scene, at the Tate Modern, produced a silhouette.

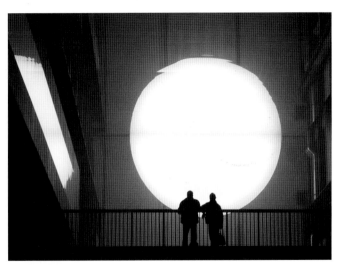

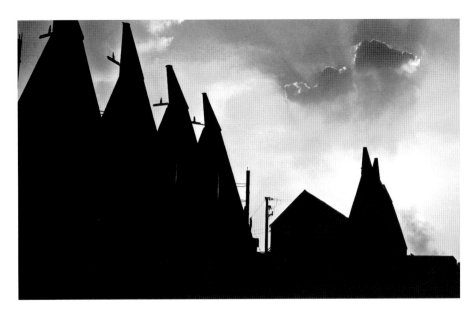

When I took an exposure reading from the sky, the sunset was properly exposed, but these hop kilns were shown only as silhouettes.

TIP

Rather than using the *Levels* tool in Photoshop (*Image > Adjustments > Levels*) use a *Levels* adjustment layer from the *Layers Palette*.

Using lens filters

With black and white film, colored lens filters are used for fine control of contrast and tone separation. With digital photography, the need for filters is reduced, but not completely, and using filters judiciously leads to better-quality results.

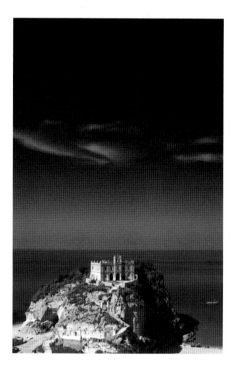

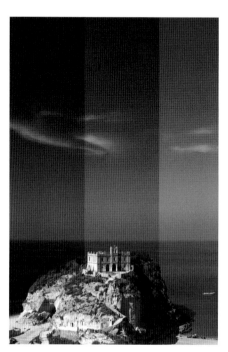

Compare this image shot with (respectively from the left) a red filter, a green filter, and with no filters.

A red lens filter can deepen an image's tone dramatically.

THE HARDWARE

Glass filters screw directly onto the lens, while plastic/resin filters slot into a holder. The holder has an adapter for each thread size, so this is much more flexible if you have a few lenses or cameras. Some lenses, like ultra wide-angles, only take gelatin filters, which are easily cut to size and fit into slots at the rear of the lens.

SKYLIGHT FILTERS

It is worth getting a good-quality, glass skylight filter (1A) with each lens and leaving it on throughout its life. This filter reduces ultra-violet light, which is especially strong at higher altitudes and causes haze in landscapes. But above all, the filter protects the lens.

COLORED FILTERS

A filter allows light of its own color to pass through, and blocks opposite colors. With black and white film, yellow, orange, and red filters cut through bluish haze and improve clouds' tonal separation from blue skies. Green filters improve foliage tones, and blue filters can reduce midday shadows. With a color image on computer, the more advanced methods of converting to black and white (*see page 72*) use exactly the same principle. Filtration can be applied to individual parts of the photograph, as if you have all sorts of esoteric red-green graduate and other colored filters. By not using colored lens filters, optical quality is unaffected, and the image can be output as both color and black and white. The only exception is the specialist Infrared filter.

> **TIP** Look out for vignetting when shooting images with a filter. It may be that the filter is intruding on the image, or that it is unsuitable for the lens.

A filter is optical-quality material, usually glass or plastic, that restricts certain colors or types of light from reaching the film or sensor.

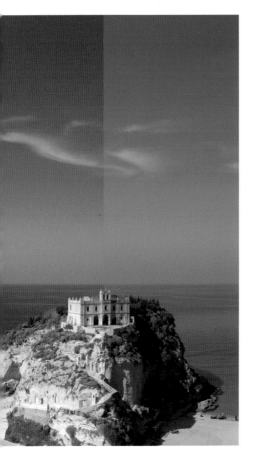

It is worth shooting tests with and without a polarizing filter. These images were taken minutes apart, in the early afternoon and with the sun directly to the left. Using a Channel Mixer method to convert part of the images to black and white, there is little to choose between them. In color there is more difference—the polarized version has brought out the turquoise in the sea to the lower right.

GRADUATED FILTERS

It may well be worth having a neutral graduated filter just in case you ever need to darken a bright sky in order to expose all parts of the image properly.

NEUTRAL DENSITY FILTERS

Neutral density filters reduce light uniformly. Their biggest use is to allow you to use a much slower shutter speed. A neutral density filter could have been used to get a long shutter speed to blur the water in this photograph of Dettifoss, in Iceland. A polarizing filter was used instead, because a polarizer is always a neutral density filter with a value of about 2.5 stops.

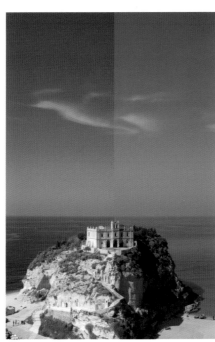

POLARIZING FILTERS

For film or digital, good-quality polarizing filters should be in the camera bag. But polarization fundamentally changes the light recorded by the sensor, so decide for each shot whether to use the filter. A polarizer cuts out reflected light, resulting in fewer, if any, reflections off surfaces such as water, glass, polished wood, and leaves. Colors are richer, skies are bluer, clouds stand out. The polarization increases as the filter is rotated, and it is also affected by the type of light and its angle. It is strongest when the filter is at 90 degrees to the sun. Disadvantages of polarization are that some parts of the sky can look too dark, especially with wide-angle lenses, and the filter reduces the light by about 2.5 stops, so for some shots, you may have to use a tripod. A further disadvantage is most

important for black and white: Without reflections, a picture doesn't necessarily look better. Especially in monochrome, where we only have tones, the polarized photograph will often appear dull and lifeless. Decide for each shot whether the polarizing filter improves it or not.

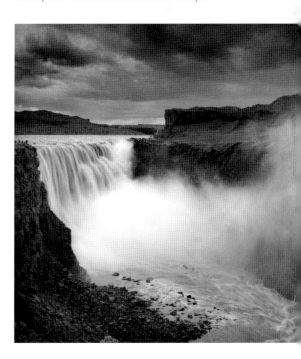

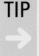

TIP A polarizing filter stops reflections from shiny surfaces since the lightwaves in a reflection travel parallel to each other. Reflections from mirrors do not behave like this.

Shooting for post-production

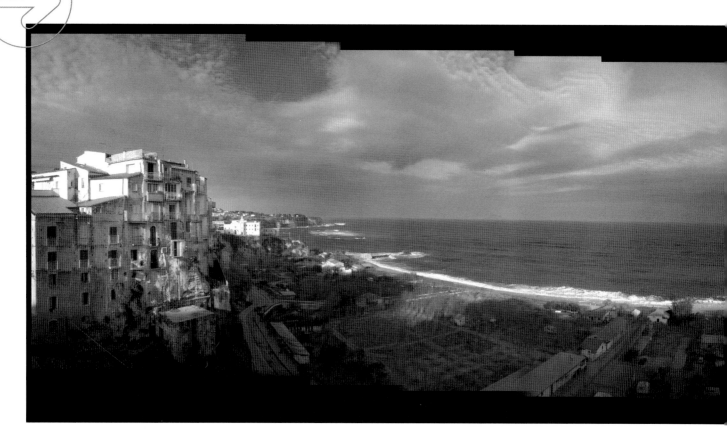

Black and white photographers have always shot for post-production, knowing that, long after releasing the shutter, the picture will be finished in the darkroom. The digital photographer is doing exactly the same thing, imagining how a scene will be rendered as black and white tones, or underexposing to ensure detail in the highlights. As well as thinking ahead and shooting, some photographs have always been taken more as raw material for subsequent manipulation, and digital imaging makes this much easier.

Extreme contrast may be a good reason to think about shooting for post-production. The exposure latitude of digital cameras is better than slides but can still not be enough if the scene contains important shadows and bright highlights. One solution is to mount the camera on a tripod and shoot once exposed for the highlights and once for the shadows, and to blend the shots on the computer. If that isn't possible, you can use a sky or other detail from a completely different picture. It can help to build up a library of material for use in such photo-montages. Skies are especially useful, but arches, doors, windows, and even statues can all be reused.

Another problem is cars, tourists, or other distractions moving across the subject. While one solution would be to blur their movements with a slow shutter speed, there are post-production alternatives. Using a tripod, take

This panorama of Tropea in Calabria has an angle of view of over 200 degrees. Ten 6-mega-pixel shots were joined manually in Photoshop. Before starting this, I checked to make sure Photoshop had enough Scratch Disk space allowed for a Photoshop temporary.

Digital gives the photographer a great deal of freedom once the shutter release has been pressed. Think creatively when you're shooting so you have everything you need when you get back.

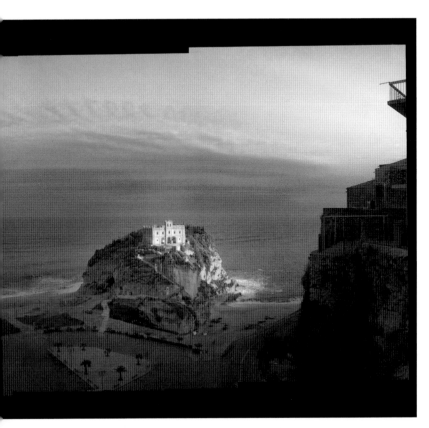

more than one shot of the image and cut and paste clutter-free parts of one image into the other. This is very similar in technique to doing a simulated multiple exposure, which we discuss later in the book (see page 122).

A fun post-production technique is to create a joiner, a photomontage where pictures are stitched together to form a bigger image. Panoramas are a popular use of this method. The joins may be so slick that it looks like a single image, or they may be deliberately left obvious. It's easier if you put the camera on a tripod, with both the tripod head and the camera perfectly level, but it is also possible to hand hold. Focus, and then switch the camera to manual focusing.

Do some test shots, check the LCD, turn the camera to manual exposure, and set the best exposure. Then shoot the images for the joiner. It is very important to ensure that the images

overlap generously. Work quickly, just in case the sun goes in or something important changes. Afterwards, use Photoshop's *Merge* feature to join and blend the images automatically. This can work well when there is sufficient common detail in each shot. Alternatively, copy each image into a layer and position them yourself. It can help to temporarily reduce the opacity of the layer that you are moving. To make smooth transitions, add a mask to each layer and use a soft brush to paint black on the mask.

 These friezes might be combined with some stock arches and Italian street scenes in a grand Renaissance pastiche. Notice how a mask is being used rather than deleting the unwanted pixels—this gives a bit more flexibility.

TIP Besides Photoshop Elements and Photoshop CS's *Photomerge* tool (*File > Automate > Photomerge...*), there are more powerful options available as Photoshop plug-ins.

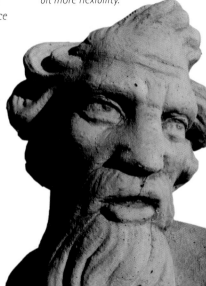

3 Digital Imaging Techniques

While a photographer should always strive to get as much right as possible when shooting, digital imaging offers a great many opportunities to rectify problems at a later date. Furthermore, digital tools can be used to enhance and alter photos in ways that simply weren't possible before. This chapter introduces the key digital tools for image editing, including all those needed to take color digital images and create great black and white compositions.

Image-editing software

Until the late 1980s, image-editing software struggled with scanned images, which consisted of pixels. Adobe Photoshop changed this, mathematically modeling pixels' relationships to one another. Image areas could now be selected intelligently with realistic, soft edges, their tone could be changed, and they could be separated into layers and independently controlled. Since then, Adobe Photoshop has been the leading software for digital photography.

Most graphics applications have a series of "palettes" that can be moved around at will.

The Adobe Photoshop CS Toolbox contains a wide range of features—many tools with similar tools grouped behind them, accessed by clicking and holding.

ADOBE PHOTOSHOP

Photoshop was developed for the Mac by Thomas Knoll, a PhD student whose father was a darkroom enthusiast. He sold it to Adobe, a software developer for the printing trade, and remains involved in its development.

Photoshop runs equally well on Mac or PC, and it does not matter which operating system you use. Many Windows users do find the system's Mac-style interface very unfamiliar, partly because millions of fluid pixels are a very different environment from the words or rows and columns of most office software. But user-friendliness has always been a strong feature of the Mac, and Photoshop's tools have always mimicked traditional photographic tools such as dodging and burning.

Photoshop has always commanded a big price premium, but it has professional-quality features. It is almost certainly the best tool for digital black and white photography, a fact evidenced by its ubiquity.

ADOBE PHOTOSHOP ELEMENTS

Photoshop Elements is a cut-down version of Photoshop and is much cheaper. It is bundled with many cameras and scanners.

PAINT SHOP PRO

Paint Shop Pro has been around for at least 10 years and continually improves. It is very good and was my own preference for many years.

OTHER IMPORTANT SOFTWARE FOR DIGITAL PHOTOGRAPHY

BATCH RENAMING

Some photographers rename new image files, sometimes including a date or description. Renaming batches of images is often a feature of software that comes with the digital camera, and there are many freeware utilities. Photoshop CS does this well. In *File Browser*, select the group of images, right-click, and select *Batch Rename*. Check carefully before clicking *OK*, because there is no undo feature.

CATALOGING SOFTWARE

It has always been hard keeping track of photographs. Some write databases with Microsoft Access or Excel. But there are packages such as Adobe Photoshop Album and Extensis Portfolio that let you build Catalogs with image thumbnails and categorization.

There's a huge variety of tools and equipment you can acquire for storing and editing your images. Historically, the centerpiece of any setup has been Photoshop, but there is a lot of software and hardware out there.

Photoshop CS has a *File Browser* with similar features, but it can drastically slow down a computer if you're accessing a folder with a lot of images. While these methods automatically record some data, such as EXIF exposure details, remember that they are only as good as the data you put in.

IMAGE RECOVERY
If the computer cannot read a memory card, do not save any more images to it. Lexar Image Rescue, Don't Panic, and many other freeware utilities can often recover "lost" files.

CD/DVD BURNING
You cannot have too many backup copies of your pictures. Copy them to another hard disk, and burn multiple copies onto CD and DVD. Don't forget to copy your camera software.

TIP Establish a solid and routine workflow but keep questioning it, especially if you change part of your system. If in doubt about data security, get an idea of "best practice" from any specialists you know.

 If your computer does not already have one, invest in a DVD writer. It's a great way to back up large quantities of data quickly, cheaply, and efficiently.

FACT FILE

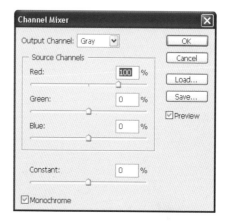
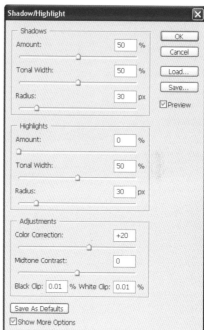

Ten quick wins—learn these features first

A Use a *Channel Mixer* adjustment layer for converting color to black and white.
B Use a *Curves* adjustment layer to control contrast.
C *Dodge* and *Burn* on an overlay adjustment layer.
D Work on a duplicate of the image layer.
E Use the *Crop* tool to perfect the composition
F Select pixels with the *Marquee, Magic Wand*, or *Lasso* tools.
G Use *Select > Feather...* for smoother selections.
H Try *Image > Adjustments > Shadow/Highlight* to adjust contrast.
I Repair images with the *Healing Brush.*
J Repair larger areas with the *Patch* tool.

TIP Download free trials of software you'd like to experiment with. These are the full product and generally work for 30 days from the first day you use them.

Scanning

Many photographers have slides, negatives, and prints that can be scanned and digitized. In this back catalog may be black and white negatives, but also color images that the photographer always suspected should have been shot in black and white. Scanned into the computer, the color channels can then be used, just like filters with film, to fine-tune the black and white version.

FILM SCANNERS

Thirty-five millimeter film scanners can scan mounted slides and film strips at high resolutions, 2,700 to 4,000 dpi, and cost from about the same as a midrange digital compact camera. Some scanners have software (ICE) that detects and digitally removes dust spots, though this does not work on most black and white film. Keep the scanner's cover closed when not in use—getting the lens cleaned is expensive.

Many flatbed scanners, such as this Canon, are versatile enough to scan slides as well as prints.

A dedicated film scanner like this one can be a compact solution in a crowded working environment.

FLATBED SCANNERS

Flatbed scanners are best for scanning prints. Look out for optical resolution, which is more relevant than the software-interpolated resolution. Many flatbed scanners have "transparency hoods" for scanning film, though the dedicated 35mm film scanners give much better quality. Flatbeds are especially useful for film formats larger than 35mm, for which film scanners are very expensive. They hold the film in pre-cut plastic mounts that have notches, so the scanning software recognizes their presence. You can also make your own film holders for unusual film sizes.

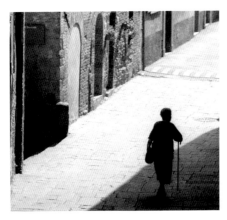

1 Select the image to scan. If you have multiple exposures of the same subject, choose one with the best highlight detail, as this can easily be lost in scanning. If a print is too big for the scanner, scan it as two or more files and merge them in Photoshop.

2 Scan directly into Photoshop using *File > Import > [Your scanner]*, which triggers the scanner's TWAIN interface. You can also scan using the software supplied by the scanner manufacturer, and with specialist programs such as SilverFast and VueScan, which offer sophisticated options.

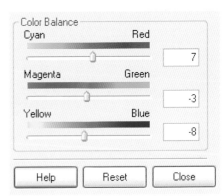

3 If the picture is color, scan it as color, even if you intend to output in black and white. If you scan as grayscale, you lose the opportunity to use channel filtration to fine-tune the conversion to black and white. Your software may allow you to make minor color corrections at this point, too.

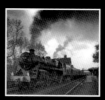

A good scanner will bridge the gap between your digital and your film image collections, allowing you to manipulate them both in the same software.

4 Switch off *Unsharp Masks* or other scanner software sharpening. These generate jagged edges, grain, and other artifacts. Sharpening is better applied very late in the image-editing process, often just before printing. Make a preview scan and examine the scan at 100% magnification. Look for highlight and shadow detail.

5 Most scanner software has histograms showing the distribution of pixels. Adjust the curve to get better tonal detail in important image areas, and refresh the preview. When settings work well, save or export them for later reuse. Aim to capture detail for all tones, especially the highlights. If necessary, you can always make dark and light scans and blend them in Photoshop.

This is the same black and white negative, scanned with the default settings and with a curve adjusted to bring out more highlight detail.

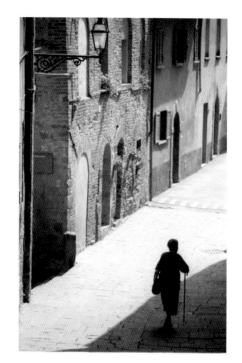

6 If scanning black and white negatives is important, a few film scanners have an LED light source whose strength can be adjusted. Nikon calls this "Analog gain," and it is like exposure control. More light is forced through the negative's densest parts, the highlights, and so the sensors capture more detail in this critical image area. Watch out, though, for possible flare or halo effects.

Applying Analog gain to the default scan produced better highlights and deeper shadows.

TIP When scanning a mounted slide, the mount will probably hide the edges of the image, so carefully take it out of the mount and use the film-strip holder supplied with the scanner.

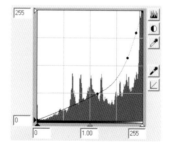

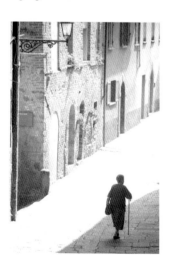

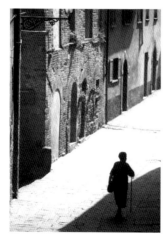

FACT FILE

Approximate print sizes for 35mm film with different scanning resolutions.

SCANNER RESOLUTION	RESULTING IMAGE SIZE IN PIXELS	PRINT WIDTH @ 300 DPI	
		INCHES	CM
2,700	3,720	12	32
4,000	5,512	18	47
5,400	7,441	24	63

Dust spots and retouching

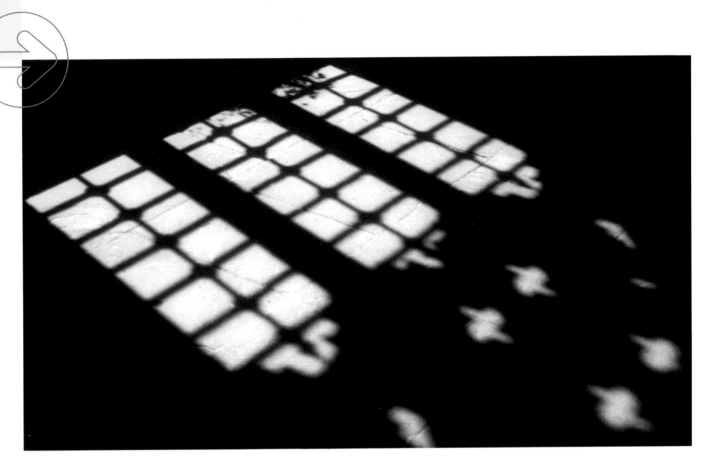

A darkroom print is often finished by dealing with white spots caused by dust specks on the negative. A small brush is used with dye matched to the print tone, which won't show on the surface of the print. Occasionally, a black spot may need to be etched out of the print using a scalpel. Obviously, all this needs care—few darkroom workers would claim never to have ruined a print. While we can avoid destroying the original with a simple copy command in digital editing, similar skill is needed to produce the best results.

Digital images may have dust specks from the scanner's glass screen, or from the original. A digital camera may have faulty or "hot" pixels that can become obvious on the picture, especially in low-light images. A JPEG image might have a particularly nasty artifact. Digital SLRs have a big problem with dust sticking to the sensor—this shows up most at smaller apertures because of the greater depth of field. Manufacturers are slowly addressing these issues with hardware and software solutions, but dust and other blemishes do occur, and we need to deal with them.

> **TIP**
> Don't clean your own CCD unless you know what you're doing. It is one of the camera's most expensive parts.

 Dust and scratches can detract from an image, but all image-editing software provides a good range of tools to repair the damage.

1 Zoom in on damaged areas, getting close enough to see the spots or other marks, but not so close that you can no longer see their context.

DIGITAL IMAGING TECHNIQUES

Prevention is always better than cure, but the serious photographer will almost inevitably have to remove dust spots and retouch images.

2 Select either the *Healing Brush* (shortcut J) or the *Clone Stamp* (shortcut S). Both tools sample pixels and copy them to the damaged area, but the newer *Healing Brush* also adjusts the repair to blend into the surrounding area.

3 Don't always try to repair damage with a single click—you want your work to be seamless. Adjust the brush size using the] key to increase brush size and the [to reduce it. Also soften the brush's edge—hold down the Shift key at the same time as pressing [.

4 Identify nearby pixels with matching texture and tones. Holding down the Alt key, click on them once—this samples the area you have highlighted.

5 Now click the pixels you want to repair, and you should see that the sampled pixels are copied into the area. Also, at the moment you click, see how there is a cross-hair at the spot from which the sample has been drawn.

6 Click again around the spot or other damage until it is invisible. Sometimes sampling from more than one area (repeating step 5) helps to hide the repair and avoid unsightly repeating patterns caused by the tool.

7 It can be quicker to drag while clicking along a line of spots or a fiber, but even with the *Healing Brush*, the repair is likely to be more obvious. Just take your time.

FACT FILE

Safety first
It can be a good idea to start off by using the *Marquee* or *Lasso* tool to select around only the area to be repaired, possibly feathering the selection with the shortcut Ctrl-Alt-D. This protects neighboring areas and, if those areas contain high contrasts, it prevents the *Healing Brush* from bleeding them into the repaired pixels.

TIP Create a copy of the image layer using *Layer > Duplicate Layer*. Apart from keeping the original, at any time you can review your corrections.

Converting color to black and white

Many camera bags contain more than one body or film backs so the photographer can swap them in seconds if the scene calls for color or black and white. Sometimes, though, you only have an image on color film and decide later that it actually works better as monochrome. You can try printing it later on black and white paper, but this doesn't always work. For one thing, photographic paper is made so that it is not sensitive to light of certain wavelengths—such as the red color of a darkroom's safelight. Unfortunately, this is similar to the orange base color of a color negative. There are special papers and other ways around the problem, but results can be unpredictable. So when you're working with film, it's better to take identical pictures on each camera.

The digital camera's sensor records a color image, as do scans of color transparencies, negatives, and prints. With some cameras and scanners, it is possible to capture the image as black and white, but this loses the color image's separate red, green, and blue values forever. This throws away valuable information that can help produce a better black and white photograph. The key objective when converting an image from color is to retain as much tonal detail as possible, especially in the highlights. As with many things, there are quick, easy techniques with little control, or techniques where you can fine-tune the results and retain the ability to adjust later.

LAZY METHOD 1: CONVERTING THE IMAGE TO GRAYSCALE MODE

Image > Mode > Grayscale makes the image record only grayscale values for each pixel. This is quick and easy, can work well enough, and saves on disk space. But there is no control or flexibility and the entire image file is changed forever—so make sure you backup your original. As you can see from the resulting image the tones are somewhat muted, though it's still possible to apply some of Photoshop's other tools to improve things. *Image > Adjustments > Levels*, for example, is quick and easy to use, once you've got to grips with histograms (*see page 48*). Again, though, this is a destructive editing technique better suited to quick jobs.

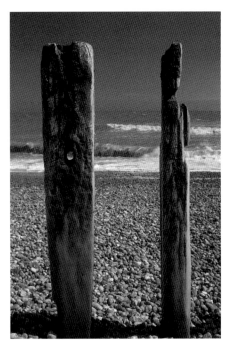

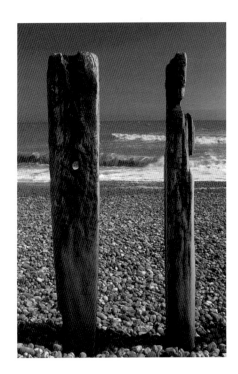

LAZY METHOD 2: DESATURATING THE IMAGE

Image > Adjustments > Desaturate tells Photoshop to make the image monochrome by setting equal red, green, and blue values for each pixel. The only advantage of this method is that you can avoid destroying your original. Select *Layer > Duplicate Layer* first and desaturate the copy. Or click and hold the New adjustment layer icon, select *Hue/Saturation*, and then drag the *Saturation* slider to minus 100. As with grayscale mode, you have no control, and you have a bigger file with the redundant color values.

TIP Using a *Desaturate* adjustment layer allows you to create color effects by reducing the opacity.

There are many ways to convert a color photograph to black and white but not all methods give you enough control over the process. Applying the better techniques lets you produce better-quality output, with fewer burned-out highlights with richer tones.

LAB MODE

"Lab" is a way of recording color by giving each pixel a Luminosity value plus values for two arbitrary color axes, called A and B. The Lab Mode method can produce better results with finer shadow and highlight separation.

1 Select *Image > Mode > Lab Color*. The picture remains in color, but notice that the window's title bar shows the file is now in Lab Color Mode.

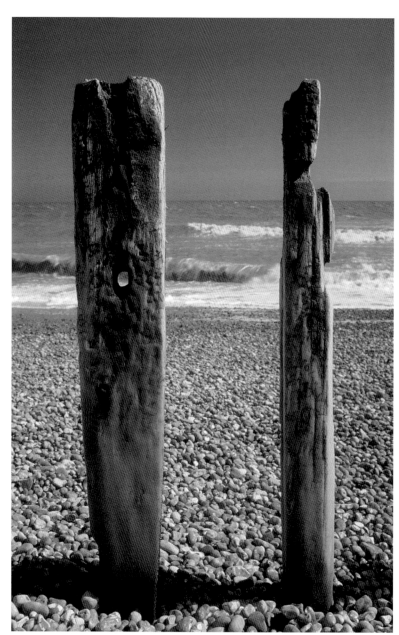

2 We only want the information in the Luminosity channel, so select the Channels palette (*Windows > Channels*).

TIP When you fist open a color image in Photoshop, examine its red, green, and blue channels separately by holding down Ctrl/Command while pressing 1, 2, or 3. This can show which channel contains the best tonal information and helps you use the *Channel Mixer* or *Film/Filter* conversion methods.

3 Click either the A or the B channel and drag it to the palette trash. In most cases, this leaves us with a finer-quality black and white image than can be achieved by simple conversion to grayscale and desaturation.

Converting color to black and white

With digital, many photographers find using a *Channel Mixer* adjustment layer and selecting monochrome output is the most natural way of converting a digital color image to black and white. Like filters for film, this technique offers much more precise control over the conversion process, allowing you to separate tones and produce a finer black and white print.

The *Channel Mixer* adjustment layer also has the big advantage of not being "destructive," unlike switching to *Lab Mode* or converting to grayscale, which both permanently change the digital-image file. With this technique, you can always adjust the black and white conversion afterwards. This might be to fine-tune the image after some dodging and burning, or changing brightness and contrast. You also have a record of how you filtered the photograph, so you can apply the same effect to a similar image. You can even restore the original to a color image.

ith black and white film, the photographer uses filters over the lens to control the light that is recorded on the negative. A yellow filter reduces blue light and cuts through haze, making the sky darker. Orange and red filters strengthen this effect, sometimes unnaturally so, while green filters can be used to distinguish various shades of foliage. The careful use of filters is part of the art of black and white photography.

1 In the *Layers* palette, create a new adjustment layer and select *Channel Mixer*. Or, from the menu, select *Layer > New Adjustment Layer > Channel Mixer*.

TIP Don't be tempted to convert to black and white using *Image > Adjustments > Channel Mixer*. Always use an adjustment layer instead—this lets you change your mind later.

2 Check the *Monochrome* output box. Photoshop now shows a black and white image. Note that the red channel slider is first set to 100%, like using a red filter with film, and that there is some cloud detail in the sky.

If you are accustomed to using filters in black and white film photography, it feels most natural to use the *Channel Mixer* method of converting to black and white, and this method often produces the best results.

3 Now experiment with moving the other channels' sliders, or key values into the dialog box, if you want. Note how setting the blue channel to 100% acts like a blue filter, lightening the sky but darkening the yellow building.

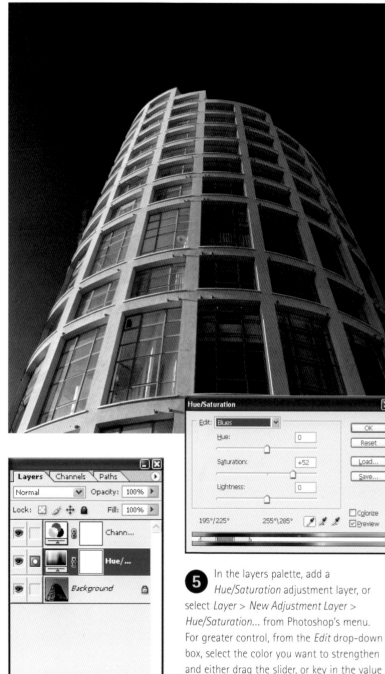

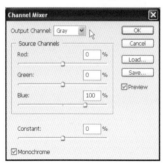

4 Sometimes you can enhance the filtration effect by increasing the image's color saturation. This is similar to taking the photograph with a polarizing filter, although it doesn't eliminate reflections.

In the *Layers* palette, select the image layer. This is to be sure you saturate the image before the *Channel Mixer* operates—otherwise saturation has no effect, as Photoshop simply applies it to an image that is already monochrome.

5 In the layers palette, add a *Hue/Saturation* adjustment layer, or select *Layer > New Adjustment Layer > Hue/Saturation...* from Photoshop's menu. For greater control, from the *Edit* drop-down box, select the color you want to strengthen and either drag the slider, or key in the value you want. Here, I have chosen to increase the saturation of only the blue channel because this darkens the sky without affecting the color of the building.

Converting color to black and white

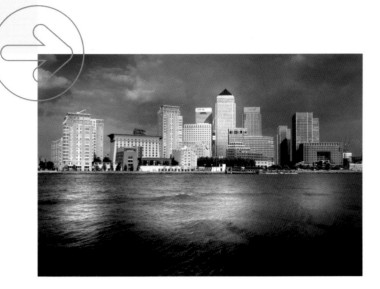

The *Film/Filter* method is another much more powerful way to convert a color image to black and white. It does not destroy the underlying image, so it has the same advantages as the *Channel Mixer* technique. The method is to use two *Hue/Saturation* adjustment layers, one that is desaturated and acts as black and white film, and a second that functions as the lens filter. By varying the *Filter* layer's hue and saturation, you control and subtly improve the photograph's black and white tonality.

1 Click and hold the new adjustment layer icon in the *Layers* palette and select *Hue and Saturation*. Change this layer's blending mode to color. This layer will now act like a colored lens filter, so double-click its name and rename it "Filter."

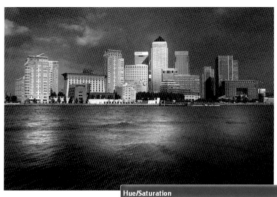

2 Click and hold the new adjustment icon again, and also select *Hue* and *Saturation*. In the dialog box, drag the *Saturation* slider to minus 100. Click OK, and you should see a black and white image.

3 Because it is making the image black and white, rename this layer "Film." Check too that this *Film* layer is positioned above the *Filter* layer.

TIP If you use the advanced methods, record actions to automate the conversion process. As this "exploded" view of my *Film/Filter* method action shows, you can always fine-tune the results.

The *Film/Filter* method is an advanced way to convert from color to black and white. It is easy to master. Decide which method works best for each image and check the results critically.

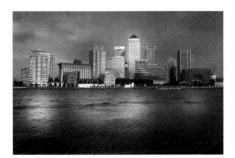

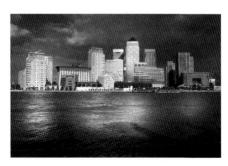
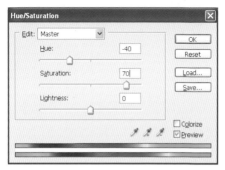

4 Now select the *Filter* layer and double-click its icon. In the *Hue/Saturation* dialog box, drag the *Hue* and *Saturation* sliders and watch the way the black and white tones change.

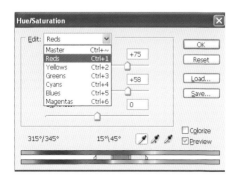

5 For further fine-tuning, double-click the *Filter* layer icon and bring up the *Hue/Saturation* dialog box. Click the *Edit* drop-down box, where it says "Master," and then you can vary each color's hue and saturation individually.

TIP Once you get used to a method, try using more than one conversion layer and masking the image.

RECAP

So which is the best method?
First, rule out the lazy methods. If you simply convert to grayscale or desaturate the image, you have little control, might destroy your original, and usually will not get the best black and white results. It is hard to choose between the other three methods.

Some photographers prefer the *Lab Mode* method because of its fine highlight gradations. I increasingly use the *Film/Filter* technique because of its flexibility, especially in fine-tuning the conversion of individual colors.

But my preference is for using the *Channel Mixer*. For me, it feels closest to using colored filters with black and white film, I get good results quickly, I can apply saturation techniques, and I can always fine-tune afterward. There are many other methods and variations too, like copying each channel into a layer and then varying their opacity. It's very much a question of using your judgment and intuition.

Whichever method you use, examine the results carefully—particularly look at how red, green, and blue object tonality varies in relationship to each other. And remember the key objective at this stage: Other techniques can improve the image, but we must first extract the maximum tonal detail into our black and white image.

Correcting over- and underexposure

Digital cameras let you check results right away, correct exposure, and reshoot the image. They also record exposure details. The photographer can learn a lot from studying these records, and you should end up with fewer washed-out, overexposed images, or pictures so dark that the subject can barely be identified. But mistakes still happen: Strong backlighting or subject color may fool the camera, or the photographer may be tired, distracted, or lazy. While the first rule is to check the LCD screen and correct the exposure in the camera, that is not always possible. Fortunately, there are things you can do in Photoshop to rescue an over- or underexposed image.

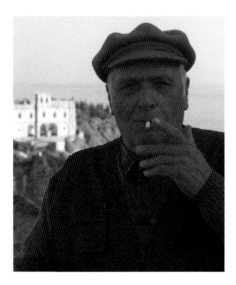

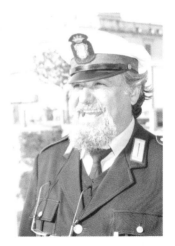

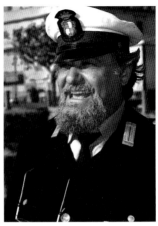

Don't automatically delete a badly exposed image. I had immediately checked the LCD screen and taken another photograph. But the first version really captured this Italian policeman's genial character, so I kept the file. When I opened it in Photoshop CS, the new *Camera Raw* feature allowed me to underexpose by two stops, producing a usable image.

Camera Raw, or the proprietory software supplied with your camera, opens the so-called RAW files. These files are "raw" in that the data from the CCD has not been processed in any way by the camera, as opposed to the more common conversion into JPEG or TIFF. The advantage is that much more subtle information, together with the camera's light meter information, is recorded. The disadvantages are that the files are large and you need to go through the Camera Raw process before the file can be used elsewhere.

1 Photoshop CS has a new feature, called *Shadow/Highlights*, that is designed to help when the background is so bright it has caused the camera to underexpose and make the subject a silhouette. But first make a duplicate of the image layer. *Shadow/Highlights* changes pixels forever, and the duplicate preserves the original.

2 *Shadow/Highlights* lightens or darkens depending on the surrounding pixels. Select *Image > Adjustments > Shadow/Highlights* and, in the dialog box, make sure "show more options" is checked.

The default settings were changed only by increasing the midtones contrast.

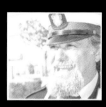 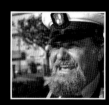

Don't automatically delete a badly exposed image. There is always the potential to recover information digitally.

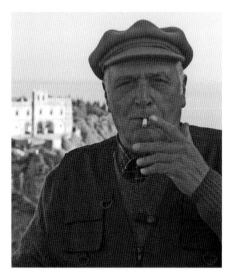

Here, because the dialog box was set to brighten shadows by 50%, the man is now less silhouetted, but the background is almost unchanged.

3 The main sliders control the percentage by which shadows are lightened and highlights are darkened. The tonal-width sliders restrict how much is treated as shadow or highlight. So a small value means the *Shadow* adjustment only affects the darkest shadows. There are also radius sliders that set the area of surrounding pixels used by Photoshop to calculate if a pixel is in the shadows or highlights. Experiment until you are happy with the image, and then click OK.

The image was finished by dodging the face and hand. The Dodge tool option was set to brighten highlights. The end result looks as though a fill flash had been used.

FACT FILE

If your camera can save pictures in RAW format, use this feature. In what looks like a badly exposed image, there is a good chance that the camera sensor may have captured much more tonal information. If the picture is saved as a JPEG file, this information will be lost. But RAW saves all image information, and you may be able to correct the exposure on computer, either using the software supplied with the camera or with Photoshop CS. For a group of similarly badly exposed RAW files, open one and correct its exposure. Then use Photoshop CS's file browser to select all the images, right-click them, and apply *Camera Raw* settings. The RAW files themselves do not change, but Photoshop remembers the settings when they are opened.

4 Many other tools are useful in correcting exposure errors—dodging and burning in some areas, for example, and exercising finer tonal control through *Levels* and *Curves* adjustment layers.

TIP If the original image is in color, it is usually best to use the *Shadows/Highlights* adjustment on the color version rather than on a black and white conversion that may have lost some tonal information.

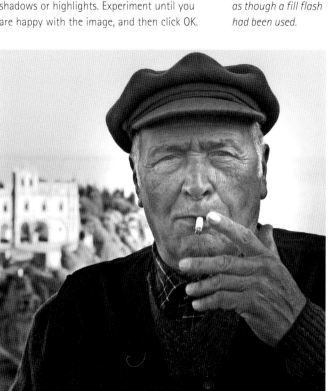

Dodging and burning

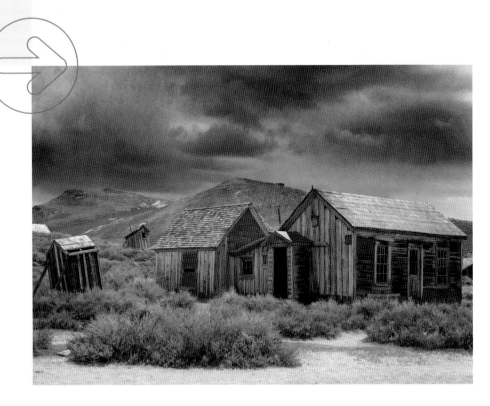

The rich and moody atmosphere of this shot could only be achieved "by hand." Each area needed attention to enhance the scene as a whole.

3 Make the background color black and the foreground color a mid-gray—for RGB images, red, green, and blue values of 128. Steps 2 and 3 are mechanical—try recording them as an *Action*.

4 Pick the *Gradient* tool (shortcut G), click the image, and drag upwards. This paints the *Overlay* layer with a gradient and darkens the sky.

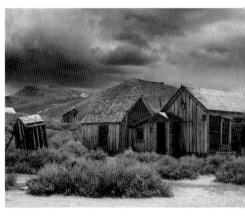

One of the pleasures of darkroom work is dodging and burning a print. Pieces of card, or hands, are moved beneath the enlarger light. This lightens or darkens selected areas of the print and is part of the art of photography. In digital imaging, dodging and burning keep their names, get tool icons, and work just like these darkroom techniques.

With a sky, try starting the gradient from just below the horizon. This can improve the transition, but watch out for unrealistic darkening of roofs and other tall objects in the shot.

1 Plan what the image should express, and look for distractions. For this wintry ghost town, the sky contained detail but looked weak, and the bright roof on the left was too obvious.

2 To darken a sky, use an *Overlay* layer and paint it with a gradient, a flexible alternative to a graduated filter. Use *Layer > New Layer*, make its blending mode *Overlay*, and check the Fill with 50% gray.

New Layer

Name: Layer 2 [OK]

☐ Use Previous Layer to Create Clipping Mask [Cancel]

Color: ☐ None ▾

Mode: Overlay ▾ Opacity: 100 ▸ %

☑ Fill with Overlay-neutral color (50% gray)

TIP Use an *Overlay* layer to burn in the edges and "hold in" the picture. This stops white bleeding in when the image is printed or mounted. Feather the overlay frame for a more subtle, softer effect.

DIGITAL IMAGING TECHNIQUES

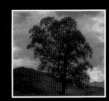 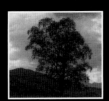

Everything on this page could have been achieved in a traditional darkroom, but at the expense of more time and chemicals.

 Here, one Overlay *layer had the gradient dragged to the top right. This was too strong and brought out the negative's grain, so the effect was softened by switching the* Blend *mode to* Soft Light.

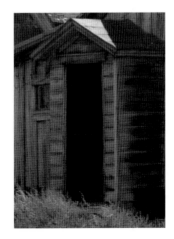

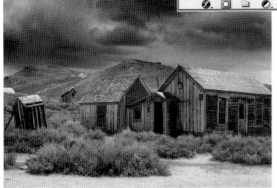

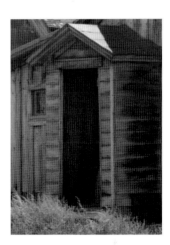

7 The *Dodge* tool works in exactly the same way. To bring out detail in the doorway, the *Dodge* tool was set to lighten the midtones.

5 If too much is darkened, click and drag again. If the effect is too dark, reduce the opacity in the layer palette, or try duplicating the layer.

6 For precise work, use the *Dodge* and *Burn* tools. These tools work best directly on an image layer and are "destructive," so always work on a copy of the image. If an image area is too bright, pick up the *Burn* tool. Change its size and soften or harden its edges to suit the area. Then drag it over the pixels—slowly and gently. To tone down the background roof, the *Burn* tool was set to burn highlights.

Faces often benefit from careful dodging and burning, too. For this Italian, looking down to the sea after a nightshift, the *Dodge* tool was set for only the highlights and put sparkle into the tired eyes.

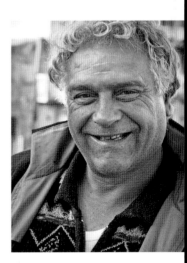

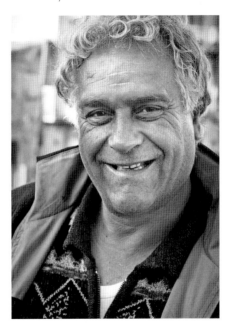

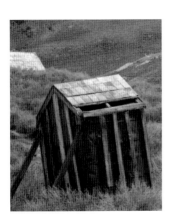 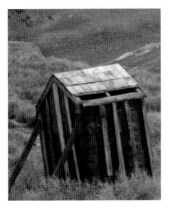

Optimizing tonal range

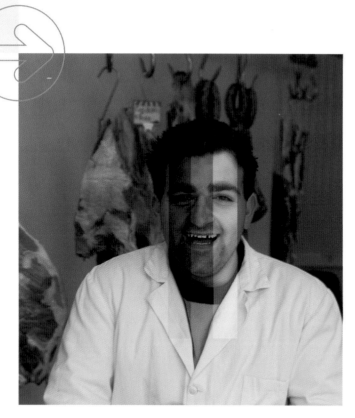

A major element of a fine black and white photograph is a full range of tones. This is partly a technical matter of producing visible detail in both the shadows and highlights. But it is also an artistic decision that respects the image, and it expresses the photographer's personal style. Some like plenty of contrast in their images, others like finely graded shadows, and many prefer a generally softer result. With digital photography, tonal range can be controlled throughout the process, as well as at the final stages before sending the photograph to the printer, the Web, or any other final expression.

 From left to right, the blue channel darkens this butcher's light skin and has strong contrast, the green is neutral, and the red channel produces the most washed-out result.

1 If the initial image is color, first use the more advanced Channel Mixer or Film/Filter methods. Retain as much tonal information as possible in the black and white image, especially details in highlights.

2 The *Shadow/Highlights* adjustment can improve the tonal balance, especially with dark subjects and bright backgrounds. Use a copy of the image layer.

TIP → Once you get used to a method, try using more than one conversion layer and masking the image.

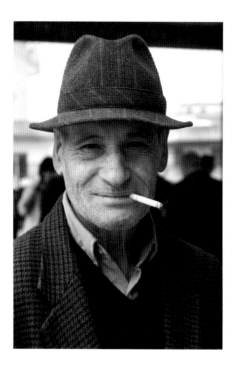

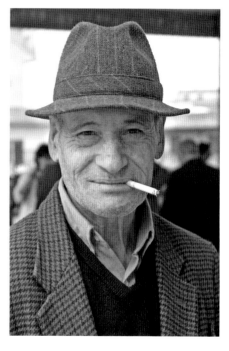

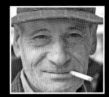
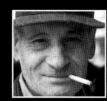

Tonal range is both an artistic and a practical consideration. An image will look better with a full range of shades, from black to white, but it's up to you to choose how those tones tell the story.

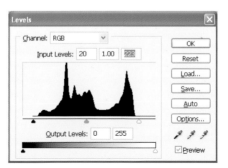

Sometimes the Auto button can produce good results, but it can easily become a lazy habit. You can also use the Eyedropper tools to sample the black, white, and midpoints.

4 Drag the triangles at the bottom of the chart to adjust the tones. The black point, the triangle on the left, is now mapped to the darkest pixels in the image. The butcher's hair, originally dark midtones, is now almost black. Similarly, the white point is mapped to the image's lightest pixels, and the apron is now white.

5 Using an adjustment layer, you can always double-click and edit. To reduce its effect, just change its opacity. To increase the effect, duplicate the adjustment layer by dragging it to the new *Layer* icon.

TIP If you want to experiment but not lose your existing work, use more than one *Levels* adjustment layer. Simply toggle the layers' visibility by clicking the eye in the *Layers* palette.

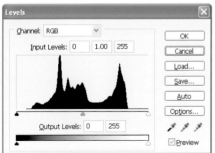

3 A picture often lacks impact because of its tonality. Blacks and whites are shades of gray. A quick way to improve this picture is to add a *Levels* adjustment layer. Use the *Layer > New Adjustment Layer > Levels*, or click the *New Adjustment Layer* icon on the *Layers* palette. The *Levels* dialog has a chart bunched in the middle: Many pixels with midtones, but no true blacks or whites—the left and right extremes of the chart. The apron is the peak on the right.

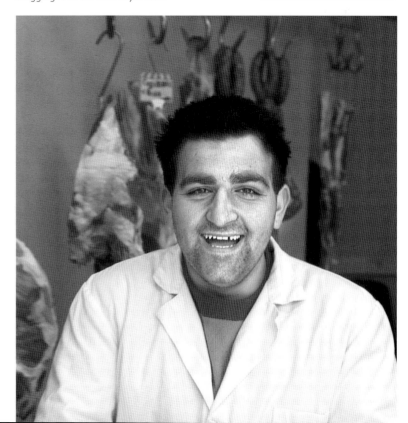

Optimizing tonal range

Tonino from Tropea in southern Italy had asked me to photograph him next to the newspaper article describing him as "master of the onion ice cream."

Another type of adjustment, *Curves*, gives more advanced tonal control than *Levels*. It is not as difficult as its reputation may suggest, and it is definitely worth learning thoroughly if you want to get the finest-quality results. It is easy to rush confidently ahead and produce photographs that, at first glance, look pretty good. But it always helps to make a plan. What should the picture express, and how can that be realized in the photograph? What are its critical areas, shadows, and highlights, and how can they be controlled individually? Such questions point the way to the image's richest expression.

An S-shaped curve like this lightens highlights and darkens shadows.

1 The color original was made black and white using the Channel Mixer method, with a high blue channel value for the subject's dark skin and for his ice-cream shop's neon lights. The converted image was low contrast but, importantly, contained detail in all areas, especially the white apron.

2 Add a new adjustment layer and select the *Curves* type. Click a point on the line, and then drag it upward to lighten the image and downward to darken it. If the point is a dark tone, shadows will be most affected; if it is a light tone, then highlights are most affected. Check your work by toggling *Preview* on and off, or hold down the Alt/Option key, which temporarily makes the *Cancel* button change to *Reset*.

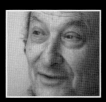
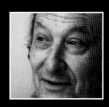

Curves can achieve very fine tonal control, though it's still certainly possible to make local adjustments with the image-editing tools.

When the curve is dragged between two points, only those tones in between are changed.

3 It is a good idea to have at least three or four points on the curve (the maximum is 14). This gives more control and helps prevent the curve kinking and producing strange tone reversals.

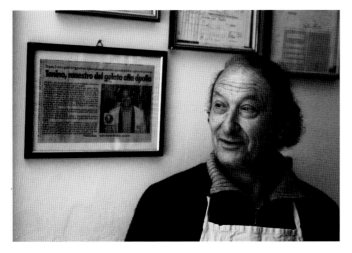

4 While you can add points by clicking the curve, it is better to sample important tones from the image itself. Hold down Ctrl/ Cmd and click a pixel of the tone you want to control. You can delete a point by dragging it off the curve and out of the chart.

The curve here has added much more contrast to the image while ensuring no highlight areas are burned out. But it darkened the dimly lit text, which was critical to this photograph.

FACT FILE

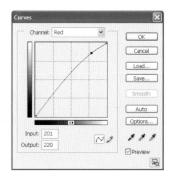

Curves demystified

Curves lets the user map individual input and output brightness values—for example, a value of 201 will be output as 220, and the image is brightened. Up to 14 brightness values can be mapped in this way, and they are represented as points on a chart. The mappings are changed by dragging these points, and the resulting curve shows how intervening input values are output. As a result, you can get finer tonal separation where it is most important in the photograph.

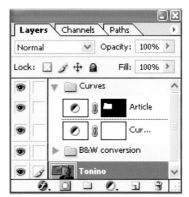

TIP A picture rarely needs the same tonal adjustment overall, so develop the habit of adjusting parts of an image using selections and masking.

5 To change the tones of just part of the image, combine a *Curves* adjustment layer with a mask. First, make a selection of the area you want to change. Here, the *Polygonal Lasso* tool was used to select just the newspaper article. Then, this selection was smoothed or "feathered," by five pixels, using Ctrl/Cmd > Alt D + D. Once the selection looks right, then the new *Curves* adjustment layer should be added. Photoshop immediately masks this layer, and your changes only affect the area you selected.

Darkening skies

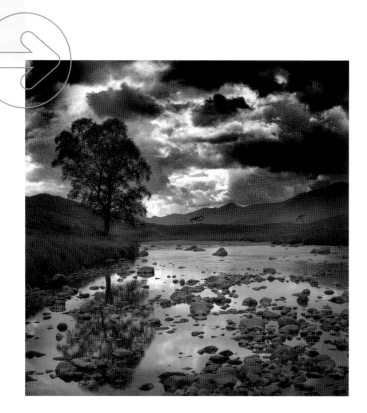

A rich, dramatic sky can be carefully crafted using not only the Curves *and* Levels *imagewide adjustments, but by touching up certain areas separately.*

1 Convert the image to black and white using either the Channel Mixer or Film/Filter methods, so you can-fine tune the conversion. Strengthen the sky using the *Channel Mixer* with a red setting of 200 and blue at minus 100.

2 Adjust tones with *Curves* or *Levels* adjustment layers. With black and white, take special care not to burn highlights such as in this image, where the sun breaks through the clouds. Use multiple adjustment layers, masking if necessary. Here at first I thought *Curves* was enough for the overall image, but I then tried changing *Levels*, toggling the new layer's visibility on and off until I felt sure of the water's lighter tones.

Black and white photographers have always darkened skies. Yellow and orange lens filters reveal faint details or pick out attractive cloud patterns. In the darkroom, the print can get extra exposure so that heavy clouds form the dominant mood of the picture.

These esthetic decisions partly emphasize what was actually there, making up for black and white film's blue sensitivity. But a darker sky also pushes the eye down into the scene. The trick, of course, is to darken it so subtly that the viewer believes that's how the sky actually looked.

The most effective digital methods to darken the sky are first to critically control the conversion to black and white, and then to use adjustment layers, particularly with the *Overlay Blend* mode. The well-converted black and white image is the best possible starting point, and the use of layers then allows the flexibility to experiment and achieve the richest interpretation of the photograph.

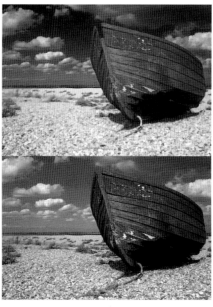

Here is the result of using the Channel Mixer *to lighten another image's red channel by 200 and reducing the blue by 100. The sky is lighter and the shadow noticeably darker and richer.*

Darkening a sky is one of the best ways to transform a photograph into a much more attractive and powerful image.

Darkening skies

3 If you feel comfortable with it, use the *Burn* tool (shortcut O) to darken pixels directly. Adjust its size and softness. Normally, though, *Dodge* and *Burn* are dangerous because these tools change the image data. After you close the file, all *Undo History* states are lost. It is far better to use overlay layers. Here, the base of the tree was dodged with a small brush setting. The clouds were heavily burnt with the *Burn* tool set mostly at 600 pixels, about one-fifth of the image size, and at maximum softness.

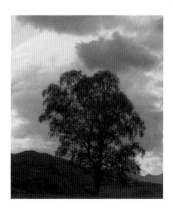

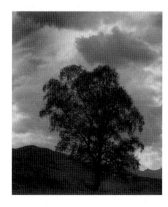

The tree to the right shows the application of the Dodge *and* Burn *tools. Notice the richer clouds.*

New Layer dialog box:
Name: Layer 3 — OK, Cancel
☐ Use Previous Layer to Create Clipping Mask
Color: ☐ None
Mode: Overlay Opacity: 100 %
☑ Fill with Overlay-neutral color (50% gray)

4 An overlay layer is like a *Dodge* or *Burn* adjustment layer. If you paint on it with a shade darker or lighter than mid-gray, the underlying image becomes darker or lighter. Add an overlay layer with the Shift Ctrl/Command-N shortcut. Set the blend type to *Overlay*, and check *Fill* with *Overlay* neutral color. If the image has a lot of grain, sometimes the *Soft Light* blend mode is better than *Overlay*.

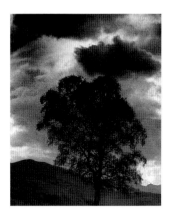

5 If the sky has even tone and detail, try painting it with the *Gradient* tool (G). Make sure the tool is set to *Linear*. Set the foreground color to mid-gray (RGB values 127, 127, 127) and the background to black. Then click where you want darkening to start, and drag upward to where you want the darkest shade. Here, the gradient tool darkens the sky. Unfortunately, it also hides all the detail in the tree. But it works well on a clear sky.

TIP → Dialog boxes in Photoshop are different from those in most programs. Even when a dialog box is on the screen, Photoshop often lets you zoom in and out and move around the image window. This is extraordinarily useful when you want to see how an adjustment layer affects specific image areas.

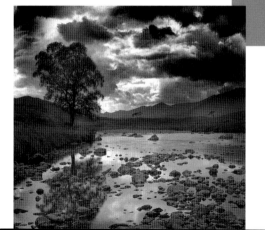

6 With an image like this, paint on the overlay layer with a soft brush (B). Again, mostly at a size of 600 px, it was used to paint black around the tree. Reduce the strength of the effect by painting with a dark gray.

Soft-focus effects

Soft focus can be used to give the whole picture a romantic, dreamy mood. It can also be used for just a part of the image, emphasizing the subject and minimizing background distractions, cars, company logos, and even faces. In the darkroom, it used to mean using plastic wrap or other transparent material, even hosiery, to distort the enlarger light. Even then, it was a little hit-or-miss. On computer, it is much more predictable, and there is now even a way to artificially create the effect of narrow depth of field.

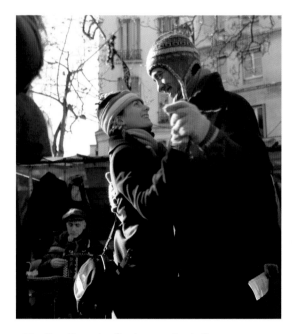

1 On a December Sunday morning in Rue Mouffetard, Paris, a low viewpoint and a wide aperture still captured messy branches and Christmas decorations visible behind the couple dancing to the accordionist.

When a picture has a lot of background clutter, blur filters may rescue an attractive image. Remember that soft-focus effects change pixels forever, so always start by duplicating the image layer. The fastest way is in the *Layers* palette, where you can drag it onto the *Create a New Layer* icon.

2 Next, create a layer mask. In the *Layers* palette, drag your duplicate layer down to the *Add Layer Mask* icon, which adds a mask rectangle to the layer thumbnail's right. Click this mask, and check that a layer-mask indicator has appeared to the thumbnail's left. Now use the *Brush*, resizing and softening it as needed, to paint onto the mask. Use black to mask the image areas you want to protect, and white to unmask. When finished, click the thumbnail and ensure that the mask indicator is gone. While the image itself should not yet look different, this mask makes the next step easier. Here, I have masked my duplicate layer. The black painting masks out the couple and the accordionist.

Depth-of-field effects are notoriously difficult to get right, but they can really make your subject stand out.

Soft-focus effects

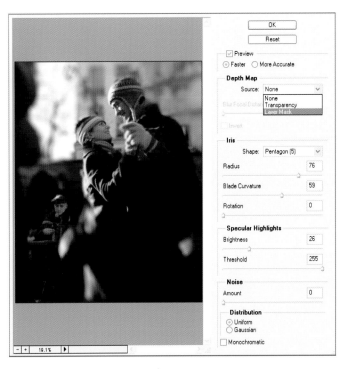

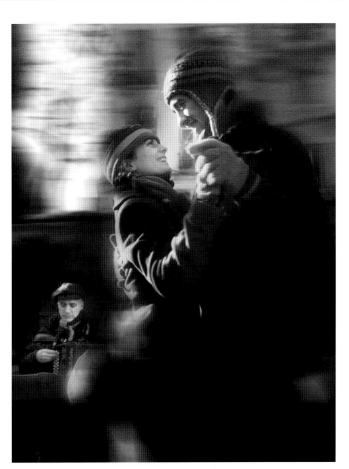

3 CS has a powerful new *Lens Blur* filter that simulates the blurring of out-of-focus image areas. Select *Filter > Blur > Lens Blur*, and in the dialog box's *Depth Map* section, select *Layer Mask* as the source. This is where having a layer mask is important, because it allows the dialog box to show a true preview.

4 To change the degree and style of blurring, adjust the lens-iris type and the sliders. When you like the result, change the *Depth Map* back to *None* (so that the whole layer gets blurred) and click OK. On the blurred layer, the couple and the accordionist are masked, so the original image shows through. If you want to adjust this, simply paint on the mask (as in step 2).

5 The other blur filters are all simpler than the *Lens Blur*, so try them out. Always use soft-focus effects on duplicates of the image layer. You can always reduce their effect by changing their opacity. The *Motion Blur* filter works well for this image.

TIP Try combining soft focus with the vignette technique, even if it is a cliché.

Retouching portraits

Sometimes a photograph is ruined by the finest detail, and this is especially true of portraits. At times, there is a need to retouch a photograph, not simply to make technical corrections such as removing dust spots, but simply to improve the image's appearance. There are a number of techniques that can improve a photograph. Taken to extremes, these could be interpreted as doctoring, or straying into photomontage. But varying the filtration, selectively lightening parts of an image, and sometimes duplicating details are skills not so far from darkroom work—just a whole lot easier.

The original portrait shot is marred by a couple of problems, not least the shiny reflections from the flash, which need to be toned down.

1 As usual, ensure that your black and white conversion extracts maximum tonal information. Here, the Channel Mixer method reproduced skin tones better with more blue, but this lost the shirt tones. So two Channel Mixer adjustment layers with masks were used.

TIP When dragging a layer, it can help to temporarily reduce its opacity so you can see its exact position in relation to the underlying layer.

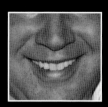

Sometimes a photograph is ruined by the finest detail and this is especially true of portraits.

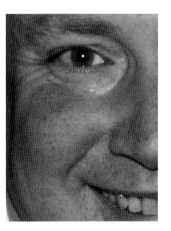
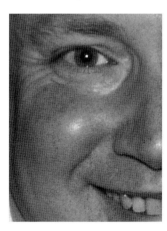

2 Select the *Healing Brush* tool (J) to make gentle repairs. The source pixels are pasted into the area, and Photoshop then blends in the repair. Retouching is often destructive. It is best to use *Layer > Duplicate* and work on the copy layer.

3 Local tone changes can improve an image. The most flexible way is with an overlay layer. Add a new layer using Ctrl/Command + Shift + N, selecting the overlay blend mode and filling it with mid-gray. Now select the *Brush*, check its size and softness, and paint lighter grays to brighten the image and darker grays to make it darker. Adjusting the overlay layer's opacity is another way to reduce its effect. Here the teeth were lightened, as was the shadow on the double chin.

FACT FILE

Using the Healing Brush
A The *Healing Brush* works like the *Clone Stamp* tool, but it only clones the texture, rather than texture and color.
B Alt+Click the region you wish to sample from, then click and drag as if using the *Brush* tool.
C You can increase and decrease the size of the brush using the [and] keys.
D Soften a brush's edges by pressing Shift+[and harden it with Shift+].
E You can paint a predefined texture from the *Tool Options* bar.

Retouching portraits

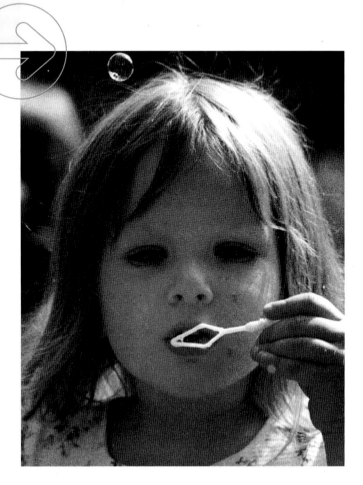

1 Using the *Lasso* tool (Shortcut L), the right eye was selected, softened, and feathered with *Select > Feather*. A feather of 10 pixels is good. The eye was copied into its own layer using *Layer > New > Layer via copy.*

2 Using the *Move* tool, the eye on the new layer was dragged into position over the squinting eye.

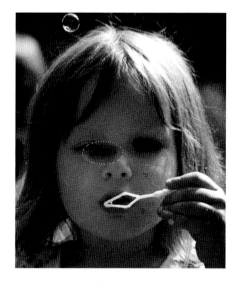

Though it is often the finer and more subtle details that spoil a portrait, other, more drastic solutions sometimes need to be employed. A different technique was needed here after the proud father noticed his little girl's face had been blighted with a squint. Even something like this need not be a problem if there is something we can clone from.

TIP → You can check the area you're selecting, especially the feather, by briefly switching to *Quick Mask Mode.*

3 *Edit > Transform > Flip Horizontal* turned the left eye around to form a right eye, and it was then moved into its final position with the arrow keys.

By copying and pasting regions of an image, it's possible to correct significant flaws, like this squint.

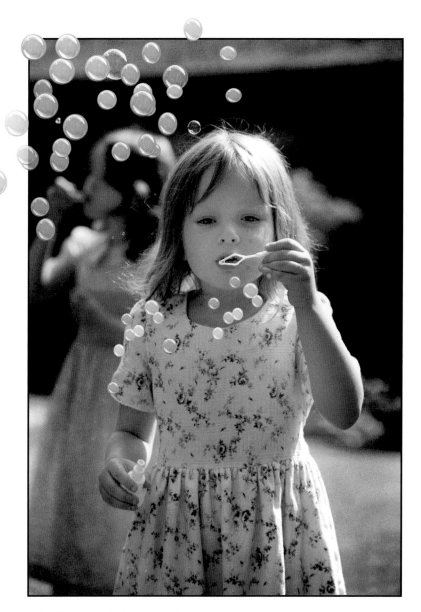

④ Using exactly the same technique, bubbles were copied, resized, and repositioned. Some sepia-toned hand-coloring completed the image.

RECAP

Retouching tips

Ⓐ The *Healing Brush* tool (in Photoshop 7 and later) is an excellent solution to removing small blemishes.

Ⓑ Look for areas where local tonal changes could improve the image. Simply paint your changes over the image using the *Brush* tool, working on a separate layer to avoid destroying the original pixels.

Ⓒ If you need to move or copy large areas, don't forget to use the *Select > Feather...* option. The higher the resolution of your image, the higher a pixel value you will need.

Ⓓ Use the *Quick Mask* mode to check the size of the feather.

Ⓔ You can move selected objects around your canvas wih the *Move* tool. Simply click and drag the selected area using the mouse or, for finer adjustments, use the cursor (arrow) keys to move pixel-by-pixel.

Removing unwanted picture elements

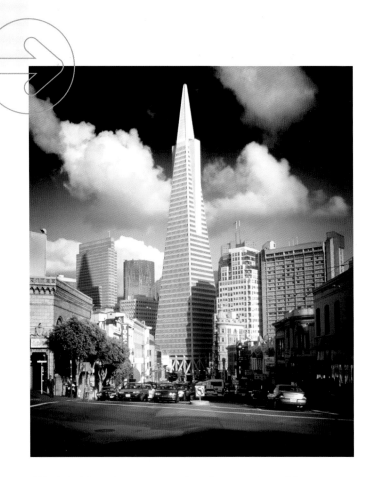

Digital imaging presents the photographer with many more dilemmas about how much improvement to make after the picture is captured. Maybe eventually the conscience is overwhelmed by knowledge of how much skill, care, and even imagination it took to achieve the end result.

Sometimes, though, it is not that we are covering up for something we have carelessly included in the frame. Often we look through the viewfinder at a scene ruined by the visual pollution of modern life. It might become part of the composition, but another answer is to take the picture anyway, consciously visualizing its skilful removal as part of the process of creating the final image. It is a personal decision, and it is certainly a slippery slope.

After removing the wires and other details, the digital image was completed by a bit of burning around the edges and a slightly warm Palladium-style tone.

1 In some cases, unwanted elements can be cropped out. Here, a tighter crop eliminated the road markings in the foreground.

2 Part of a streetlamp on the right was more distracting. To remove it, the *Clone Stamp* was selected because it copies sampled pixels directly. Its size was adjusted with the] key to 90px and then its edge was softened using Shift [. First, we need to tell Photoshop which pixels contain similar cloud and sky. So, holding down the Alt/Option key, an area to the lamp's left is clicked. Now we just stamp on the repair area, moving the mouse a tad each time, until the work is indistinguishable.

3 Photoshop gets its sample from an area relative to your first stamp. This helps avoid repetitive patterns. It also means carefully choosing the right starting point—here the sample came from a point too low and the stamp included part of the building.

This shows what happens if you do not soften the Clone Stamp—note the repair's hard edge.

Photographers take great pride in getting the image right in the camera, but black and white workers have always known that many improvements can be made in the darkroom. Cropping, changing local contrast, and dodging and burning are so integral to enlarging a negative that they are seen as skills. Some regard others, like replacing skies, as downright trickery.

4 The *Healing Brush* is a newer tool that partly replaces the *Clone Stamp*. It works similarly but examines the area around the repair and then tries to blend in its work. It can be much quicker to work with, and can sometimes be dragged rapidly over objects such as the wires on the left of the picture. The *Patch* tool works like the *Healing Brush*. Select with it an area and, as you move the tool, the selection picks up the values from where you move the tool. As soon as you release the tool, pixels are copied and blended.

5 Here the *Healing Brush* was about twice the width of the wire and was very soft. It did quite a good job of blending as it was dragged down the wire. But notice how some dark shades from the building have bled into the sky. This can be prevented by using the *Marquee* to select only the sky and restrict where the *Healing Brush* looks for its blending data.

TIP Do only as much removal as you need to and build it up very gradually. If you work on small layers, you can always reduce their opacity to adjust the strength of your work.

6 Where there is a strong pattern, you can also try to manually copy a patch. First select the area to repair, feather the selection a little, then drag the selection to where you want to get the patch. Now activate the *Move* tool (Shortcut M) and hold down the Alt/Option key as you drag the patch into position. Fine-tune positioning with the arrow keys.

7 Finally, the *Clone Stamp* or *Healing Brush* tools can be employed to tidy up any minor mismatches left over from patching.

Changing backgrounds

Some photographs have a fine subject, but a poor background, or a grand scene lacks foreground interest. It is time to consider changing the background. It is nothing new to change a photograph's background or replace a featureless sky. But it is much easier with digital imaging, and even more so in black and white, where matching colors is less relevant. Simply place two image layers in the same file and make the top layer partly transparent. This technique can be used for one-off specials, but why not build up a negative file with skies, sunsets, and stock backgrounds?

2 The key is preparation of the foreground picture. Zoom in and carefully select small areas with tools such as the *Marquee*, *Lasso* and *Magic Wand*. Before deleting pixels, feather selections by one or two pixels to make joins less obvious. Or delete with the eraser, changing its size and edge softness as often as needed. If you notice some accidentally deleted pixels, you do not always need to undo all your work. Make a selection in the original layer around the area you need to restore. Then *Layer > New Layer > Layer via Copy* (Ctrl/Command+J) places these pixels in their own layer, which you can drag to a position in the *Layers* palette above the layer where you are editing. Merge it into your working layer using the Ctrl/Command+E shortcut.

3 Here, the Magic Wand's tolerance was set to 15 before clicking a tile—Photoshop extended the selection across most of the roof, leaving out the statue.

> **TIP** An alternative is not to delete, but to add a layer mask to your working area. Then use the *Brush* tool, painting white to add to the selection and black to deselect pixels.

4 Eventually you will be left with just the part of the image you want to use. Save the file at this point.

1 Start by copying the foreground image layer with *Layer > Duplicate*. Add a new layer and fill it with a contrasting color, as this helps show where you have cut out pixels.

> **TIP** Use Q to toggle the *Quick Mask* mode.

5 Open the background file, and, to avoid overwriting the original, immediately save it as a new file. Check both background and foreground files using the same *Image Mode*. Then move the windows so both are visible, and activate the foreground's window by clicking its title bar.

Consider how your subject might look against a different background. Here the clouds add a much more gothic feel than the complicated, distracting roof.

6 From the *Layers* palette, drag the cut-out layer and drop it into the background's window. Resize and position it using *Edit > Transform*. If there are fringes around the foreground, a soft *Eraser* tool can help blend the pictures.

 Here, the sky was resized before the image was cropped.

7 Do the black and white conversion now. If needed, convert each image separately to achieve a balanced result.

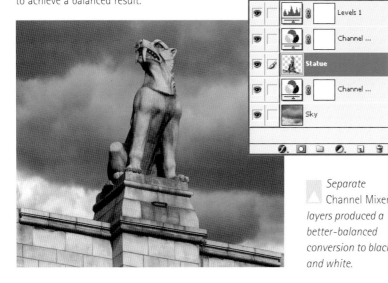

Separate Channel Mixer layers produced a better-balanced conversion to black and white.

FACT FILE

Reality factors

Check the light direction and the angle of view look right. The appearance of the image may be improved by flipping one layer with *Edit >Transform > Flip Horizontal*. Here the same sky is flipped, which makes an appreciable difference to the images. The lower one seems more convincing.

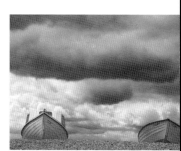

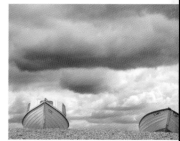

Check that the textures of the two images appear consistent. It may be visible that they came from different sources or show noise due to higher sensor sensitivity. You can hide some mismatches with *Filters > Artistic > Film Grain*.

Check too that focus is consistent—you can always use Photoshop CS's new *Filters > Blur > Lens Blur* filter (*see page 88*) over one of the images. Where appropriate, you could also use the *Blur* filters to create a deliberate focus mismatch and thereby create a differential focus effect (*see page 20*).

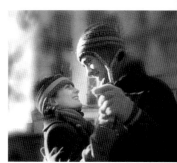

Sharpening

Sharpening is an increase in contrast between adjacent areas of pixels. The pixels near the edge are slightly darkened on the edge's dark side and lightened on its light side. As a result, the picture appears sharper and more focused.

WHEN TO SHARPEN

Digital images have inherent softness and benefit most from sharpening. Digital cameras and scanners have sharpening options that can produce acceptable results, if applied gently. But they can easily produce edge artifacts and ugly, hard edges. In general, it is best not to sharpen until the last stages of the process, sometimes only when you are preparing to print the photograph.

HOW TO SHARPEN

The key is to do as little sharpening as needed, and to do so in selected areas. If you are using RAW images, notice that Photoshop's *Camera Raw* feature sharpens images by default. Photoshop has a number of methods such as the *Sharpen* tool, which lets you paint sharpening with a brush. But normally, the best technique is the *Unsharp Mask* filter, named after an old compositing technique.

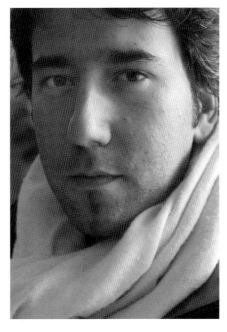

1 Sharpening changes pixels, so work on a copy of the image layer. Also, it only works on a single layer at a time, so it can be better to make a copy of the whole file and flatten out any layers.

2 Often, you only want to sharpen parts of the picture. Use the *Marquee*, *Lasso*, and other selection tools and then make sure you *Feather* the selection. Then use *Filter > Sharpen > Unsharp Mask*. The dialog has a small preview window, but it is usually easier to move the dialog box to one side of the screen and view the whole image at 100%. You can zoom in and move the image even when the dialog box is showing.

3 Adjust the *Amount* by which the image should be sharpened. For a print, expect to set this somewhere between 100 and 200%. *Radius* sets the edge width. Normally, this is kept low, maybe .5 or 1 pixel.

A high Amount *setting means unnatural sharpening. Here, the maximum setting, 500%, produced a strong edge in the white of the eye, which seems significantly at odds with the original image.*

High Radius *values mean thick edges and more contrast. Working from the same original as above, the* Radius *here was set at 50 and the* Amount *at a relatively modest 200.*

TIP Sharpening is more obvious onscreen than on a print because the screen resolution is lower than the printer's.

Sharpening images can bring more life into them, but it's important to remember that this is just a computer algorithm—it cannot make up for poor focus.

Drag

 



Sharpening images can bring more life into them, but it's important to remember that this is just a computer algorithm—it cannot make up for poor focus.

4 Drag the *Threshold*, which is how much pixels must differ from their neighbors before the filter recognizes them as edges that need sharpening. A low value picks up small brightness variations, and means more "edges," sometimes even sharpening image grain or noise. A higher threshold value means pixels must really be different from their neighbors, so this is better for evenly toned areas such as clear skies or skin.

If a high threshold value is used with detailed areas, little sharpening is visible.

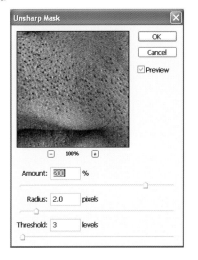

5 There are more advanced sharpening methods that you may want to try. While these use still the *Unsharp Mask* filter, generally they first refine how edges are selected. The most common ways rely on *Edge Masks*. To find out more, look up "selective sharpening" in Photoshop's help files.

Sharpening

4 Simulating Classic Darkroom Effects

Black and white might be said to be one of the more artistic areas of photography, and it is certainly something in which professionals and amateurs alike take a great deal of pride. Long before Photoshop and its ilk, an array of tricks was developed and refined in traditional darkrooms. To stand any chance of competing, the digital photographer must be able to reproduce these effects. This chapter looks at recreating the look and feel of some of the craft's artistry.

Grain effects

Grain is divisive. Some photographers detest it and, when they need faster film, choose the more modern, smoother emulsions. Many others regard grain as the big attraction of black and white, prefer older, grainier films, adjust processing methods, and seek out ultra-fast ISO 3200 films. With digital photography, grain is no longer the irreversible result of film type, but something we can easily add in Photoshop.

Esthetic reasons for using grain include building the mood of a picture. Graininess can bring out the bleakness of bad weather and a bleak landscape. In a brighter picture, it can also give a shimmering, pointillist effect. Skin tones, too, can get a sparkle or a roughness.

Grain can be useful as well as attractive. It can blend parts of a photomontage and help print gradients by eliminating banding. It can also add a texture that breaks up blocked shadows and is especially useful for adding detail to blown highlights.

Photoshop has a number of filters that add noise—a random pattern. But here we will use the film grain filter because it adds an even pattern to shadows and midtones, and a smoother pattern to lighter areas. We can fine-tune it, maybe just adding grain in certain parts of an image. And, as it is a destructive change, we can take care with applying so that we can remove it, too.

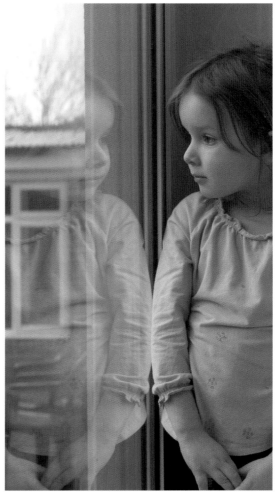

This photograph was taken on a gloomy winter day at ISO 1600. Even before cropping onto the face, there were already some digital noise and artifacts.

TIP If you combine pictures from sources with different textures, such as digital images and scanned negatives, applying a little film grain can blend and hide the different sources.

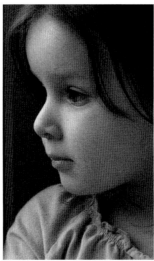

1 Adding grain is a destructive change, so start by copying the layer to which you want to add grain. In the *Layers* palette, drag the image to the *Create a New Layer* icon, or use *Layer > Duplicate Layer*.

TIP An alternative to film grain is to add noise with *Filter > Noise > Add Noise*. This filter's pattern is more random than film grain.

Adding grain is partly a simple esthetic decision, creating mood and building texture. It can also help rescue pictures with gradients, blocked shadows, and blown highlights.

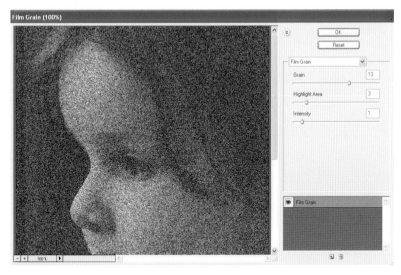

2 Select *Filter > Artistic > Film Grain*. This shows a dialog box with up to three panels. You do not need the middle panel with filter-effects thumbnails, so hide it by clicking the little button to its top right. Notice also the Photoshop icon—this switches the film grain effect on and off in the preview window.

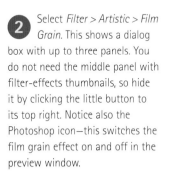

3 Now you should just see the preview and sliders. Move the *Grain* slider to the right, and the grain size increases, as if you were using faster film. The *Highlight* and *Intensity* sliders control the areas around the grains and the contrast, brightening the image. If necessary, adjust the layer's opacity or use a *Levels* or *Curves* adjustment layer to fine-tune the overall brightness.

FACT FILE

Highlight patrol
This photograph shows how adding grain can put some detail into blown highlights, here on the woman's nose and cheek. The hat was masked off, and I only applied film grain to the rest of the image. Incidentally, film grain also covered up for the picture being slightly out of focus.

Lith film effects

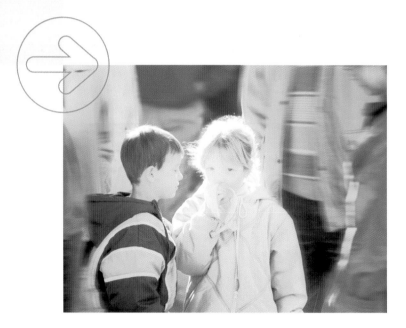

Lith printing is a darkroom technique in which you overexpose suitable photographic paper and then partially develop it in lith developer. The technique produces prints with delicate highlights, midtones that are soft and very warm, and shadows that are hard, cold, and often grainy. The results can vary widely and are sometimes difficult to reproduce, but the experimentation is fun and addictive, and can create subtle, very beautiful prints. In the digital darkroom, we can simulate lith printing. Working on the image in two layers, we colorize the highlights and let grainy shadows show through. Apart from being much quicker, reproducing the effect digitally is much simpler, and the results can be equally attractive.

1 If the original picture is in color, convert it to black and white. (Remember to try different combinations of channels for varying effects.)

2 To make things clearer, name the background layer "Shadows." In the *Layers* palette, duplicate this layer by dragging it down to the *New Layer* tool or by using the palette's menu. Rename this new layer "Highlights."

3 In a lith print, the highlights and midtones are soft and finely defined. To do this, check that you have selected the *Highlights* layer, then apply *Image > Adjustments > Curves*. Drag the bottom left marker of the curve upwards, making the shadows very pale. An output level of around 90 works well.

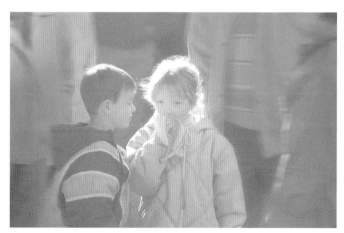

4 The shadows need to be hard. Check that you have selected the *Shadows* layer, and again apply *Image > Adjustments > Curves*. Drag the curve's top right marker to the left, which washes out the highlights and midtones in the picture.

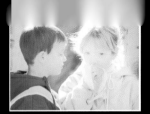

Lith printing can create delicate, moody images with warm, subtle highlights and hard shadows. As a darkroom technique, it can be unpredictable and time-consuming. But you can achieve similar results quickly with Photoshop.

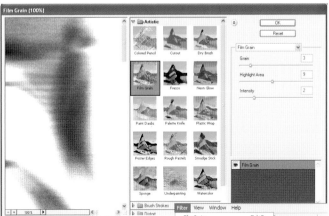

5 Depending on how much grain you want, apply some film grain to the *Shadows* layer using *Filter > Artistic > Film Grain*. So you can adjust it later, it's a good idea to work on a duplicate of the *Shadows* layer.

6 Now we want to add a typical warm lith print color to the highlights. Select the Highlights layer, and apply *Image > Adjustments > Hue/Saturation*. Check the *Colorize* box and make both the *Hue* and the *Saturation* around 35, depending on how warm you want the image.

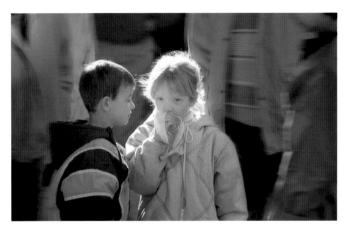

7 To get the grain to show through, change the *Highlights* layer's blend mode to *Multiply*.

8 Many lith printers finish the prints with selenium or gold toner, so experiment with different effects. With digital techniques, you can always take part of the original image, such as the banana, and add this to the lith print.

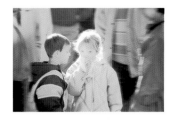

FACT FILE

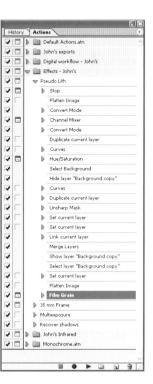

Setting up an Action
A Open the *Actions* palette, by default tucked behind the *History* one.
B Click on the *New Action* button (next to the trash can, bottom right) and give your action a name.
C Use the *Record* and *Stop* buttons as on a cassette deck, but here they record the tools and settings you use.
D "Play" the action either with the button here, or from the *Batch* menu.

Lith film effects

Sepia and other tones

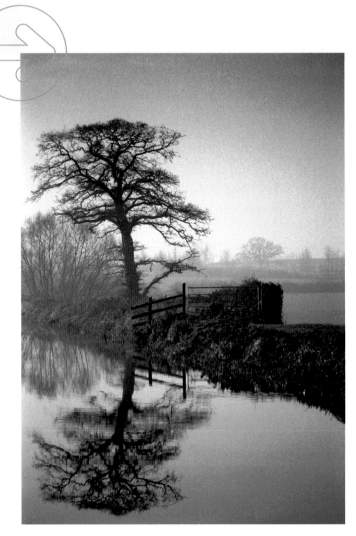

Digital photography makes toning very easy, controllable, and adjustable. There is also more than one way to do it, but essentially they're all just about adding a colored adjustment layer. One way is to add a *Hue/Saturation* adjustment layer, check the *Colorize* box, and then play around with the *Hue/Saturation* sliders. A hue of 20 and saturation of 20 produces a good sepia tone. There is nothing wrong with this method, but here we will look at an even more flexible method using *Curves* and different color channels.

The classic sepia tone lends an image an instant historical feel, and can still look good.

1 Start with an image that looks black and white onscreen. Also check the window's title, and if the image is not in RGB mode, use *Image > Mode > RGB Color*. If the image has any layers, Photoshop will ask if we want to flatten them—choose *Don't Flatten*, because there is no need to destroy any image data with this technique. Click the *New Adjustment Layer* icon in the *Layers* palette and choose *Curves*, or use the menu and select *Layer > New Adjustment Layer > Curves*.

Sepia toning symbolizes more than just the chemical process of aging and discoloration of a black and white photograph. It is part of our cultural background, hinting at old ways and the passage of time. In this sense, it can be both attractive and risk becoming a tired cliché.

Photographers use many different toning solutions to reproduce this antique effect or to add other tones. Toners such as selenium, thiocarbamide, and gold can both enhance the print's appearance and give it greater archival permanence. Precise tonal control is achieved by varying paper type and development processes, toning time, and solution temperature, and even by mixing your own chemicals.

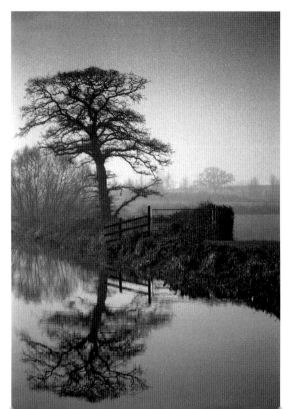

Toning has always been part of the art of black and white photography. It can completely alter the mood of a picture, and can also be the basis for other effects.

2 From the drop-down box, where it says RGB, select the red channel. This lets us add or subtract red tones. Click the curve and move it gently up to the left. Use the mouse to drag, or try the arrow keys if you feel these give you more control. Click Alt/Option and *Cancel* to reset these changes. Working from bottom left to top right, the curve represents the way the original "input" pixels' shadows, midtones, and highlights are output. Here, we are holding the curve at the black square and therefore adjusting the highlights. The input and output values mean that pixels with a red value of 187 will be output with a value of 214.

3 Select the blue channel and drag it slightly down to the right. This makes the black and white image appear less blue —or more yellow.

TIP When you click *Cancel*, try holding down the Alt/Option key. This changes *Cancel* to *Reset* and resets the curve without closing the dialog box.

4 You can also adjust the green channel, but for this sepia effect, we don't really need to do so. Click OK. We are now left with a richly toned image and an adjustment layer that we may double-click and fine-tune.

RECAP

Lights, camera, action
A So that you can repeat favorite toning effects, record them as Actions.
B Here, *All my tones* runs a series of actions, each of which adds a *Curves* adjustment layer to replicate a toning process, but then switches off the layer's visibility.
C This last step lets me then go through, switching on each layer's visibility and deciding which effect I like most and want to fine-tune.

Split toning

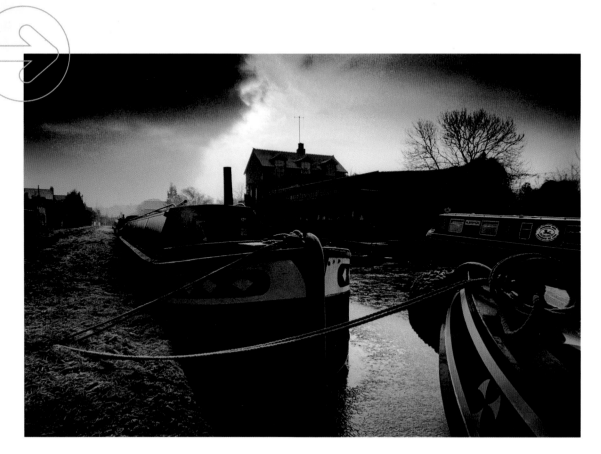

This split tone effect creates a rich image, evocative of the smoky industrial times that these boats hail from.

Fully toning a photograph can produce beautiful results, but split toning can often have more interesting outcomes. One technique is to interrupt sepia toning when only the highlights have picked up the sepia tone, and when the rest of the photograph still has true grays and blacks. This may be the finished print, or it can then be briefly immersed in a blue toner that works from the shadows. This produces a split-toned photograph with rich blue midtones and shadows as well as warm sepia highlights. There are many other variations, and experimentation is half the fun.

With digital techniques, even more combinations of tones are available, and the process is more easily repeatable. We also have more than one way to achieve the same result, and mostly these allow us to reopen the file and fine-tune the toning. So choosing a method is a matter of personal style.

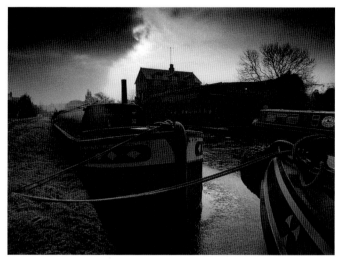

1 Here, we are going to replicate a sepia highlight and blue shadow split-tone effect. Start with a black and white image in RGB mode. Providing the image onscreen is black and white, there is no need to flatten it, unless you really want to save on disk space.

 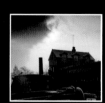

Split toning is an advanced technique where a black and white photograph is toned with more than one tone, such as sepia and blue. Careful choice of colors can add new expressiveness to the image.

2 Click the *New Adjustment Layer* icon in the *Layers* palette and choose *Color Balance*. In the lower half of the *Color Balance* dialog, the *Tone Balance* section lets us adjust the shadows, midtones and highlights separately. Select *Shadows* and drag the *Yellow/Blue* slider to the right, and drag the *Cyan/Red* slider to the left. Click OK, and we now have a rich blue tone in the darker parts of the image. If you want to adjust this, double-click the layer's icon. Also, name this layer "Shadows."

3 Now create another *Color Balance* adjustment layer. This time, in the *Tone Balance* area, select the highlights and drag the *Yellow/Blue* slider left towards yellow and the *Cyan/Red* slider towards red. Because this image is quite dark, it may work well if the midtones also pick up this tone. So repeat this with the midtones. Finally, name this layer "Highlights."

TIP Instead of *Color Balance*, you can use *Curves* or even *Hue/Saturation*.

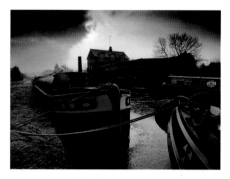

4 So far, we have one tone on top of the other, not really a split tone. The solution is to adjust the blending mode. Right-click the *Highlights* layer, choose *Blending Options*, and you should see the *Layer Style* dialog. In the *Blend If* section, there is a black triangle below the *This Layer* slider. Watch carefully how the image changes as you drag this black triangle to the right, to a value of about 60. You should see the blue tone showing, and with a sharp edge. This is because we have just set blending so that pixels in the current layer with a value below 60 will be excluded from blending. In other words, pixels darker than 60 in this layer will not show in the image. Do not close this dialog yet.

5 To split the tones, we need this blend value of 60 to be a range of values so that we get smooth transitions between the tones. Hold down the Alt/Option key and click the right side of the black triangle, dragging it away to the right and splitting the triangle. Drag it to around 200. As you do so, watch how the edge of the transition becomes smoother. Now we have a split-tone image that we can fine-tune later. We can also split tone other photographs with identical settings.

FACT FILE

Duotones, tritones, and quadtones
Another way to produce split tones is to use duotones, tritones, and quadtones, which simulate the colored inks of a printing press. Using *Image > Mode*, convert the image to grayscale, and then to duotone. The dialog's drop-down box gives a choice of two to four colors.

Variations
Image > Adjustments > Variations shows a dialog box where you can select shadows, midtones, and highlights, and click thumbnails to add blue, subtract red, and so on. It is very intuitive and quick. However, it changes the image destructively.

Hand-coloring black and white images

This splash of color gives this picture a fun feel, and emphasizes the juggler's costume.

1 Start with a black and white image in RGB mode. It may have adjustment layers—we do not need to flatten it. Consider whether you want to add a sepia or other color tone. Here we will start with an image with a sepia tone—blue also works well as a base color.

2 We will start by using Photoshop CS's new *Color Replacement* tool, which samples a pixel and then becomes a brush that paints only closely matching pixels. How closely they match is determined via the tool's *Tolerance* setting. This can be the quickest way to paint clearly defined objects—such as the juggler's hat and trousers. The tool is found in the toolbox, under the *Healing Brush*.

Before color photography became widespread, it was possible to have a picture colored by hand. The technique is not difficult, but it can be time-consuming and needs patience and care. A small brush is used to paint dyes onto the photograph, gently building up color. There is always the risk of a careless smudge, or dye dripping from an overloaded brush, and an hour's work might be ruined. Get it right, though, and you have a unique picture. On the computer, hand-coloring takes time, because no automatic tool can decide for you what colors to apply, and where. But it's essentially just an exercise in selection, masking, and using *Hue/Saturation* adjustment layers.

Hand-color works well for weddings. You can digitally hand-color a black and white image using an accent color, such as for the flowers. Find an old car, or try coloring a conspicuously modern object.

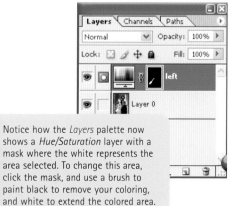

TIP
Notice how the *Layers* palette now shows a *Hue/Saturation* layer with a mask where the white represents the area selected. To change this area, click the mask, and use a brush to paint black to remove your coloring, and white to extend the colored area.

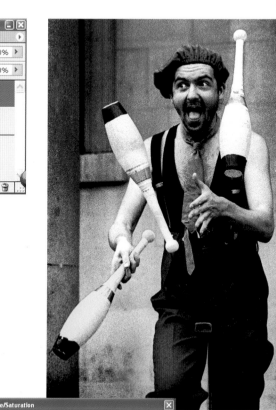

3 Choose your *Foreground Color*, and simply paint the area. The color is added to pixels matching the color of the first pixel that you paint. The disadvantage with the *Color Replacement* tool is that we are painting directly onto the image. This will result in a bigger file and is harder to adjust.

4 It is better to select the object you want to color and then create a *Hue/Adjustment* layer. To select the object, select a part of it with the *Marquee*, *Lasso*, or *Magic Wand*. Switch to the *Quick Mask* (shortcut Q), and you will see that most of the image is colored. Then select the *Brush* tool (shortcut B), zoom in, and use white to paint the object. Painting with black removes pixels from the selection. When the area is clearly defined, switch off the *Quick Mask* (shortcut Q) and you should see the "marching ants" around the area. It is often a good idea to feather the edges of this selection by clicking *Select > Feather* and choosing a small value; 1 or 2 will do.

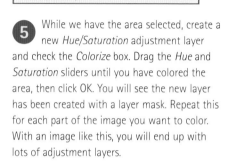

5 While we have the area selected, create a new *Hue/Saturation* adjustment layer and check the *Colorize* box. Drag the *Hue* and *Saturation* sliders until you have colored the area, then click OK. You will see the new layer has been created with a layer mask. Repeat this for each part of the image you want to color. With an image like this, you will end up with lots of adjustment layers.

Solarization and the Sabattier effect

A perfect digital alternative to the messy chemical trickery of the Sabattier effect.

The half-negative, half-positive look of a solarized picture is closely associated with the experimental work of Man Ray, an American photographer who worked in 1920s Paris. Solarization and "the Sabattier effect" tend to be used to refer to the same effect: Flashing photographic paper while it is still in the developing dish. The print's tones are partly reversed, with lighter parts going dark, but shadows and midtones unchanged. If the developing solution is still, the chemicals near dark areas are partly exhausted, reducing the effect to give light borders, known as "Mackie lines."

In the digital darkroom, the simplest way to achieve this effect is with the menu: *Filters > Stylize > Solarize*. It's simple and can produce good results but should be used on a copy of your image. Immediately afterward, you can reduce its effect by using *Edit > Filter*. But that is the only control you have over the process. The technique shown here, a W-shaped *Curves* adjustment layer, can be fine-tuned later, gives much more flexibility and control, and can produce better results. It is also just as simple to use.

TIP Try making a negative of your image by *Image > New Adjustment Layer > Invert*. This produces an effect similar to using a paper negative.

1 Start with a black and white image. It can be RGB, grayscale, or any image mode, and can have adjustment and editing layers. Just click the top layer in the *Layers* palette and make sure it is selected.

2 Click the *New Adjustment Layer* icon in the *Layers* palette and select *Curves*, or use *Layer > New Adjustment Layer > Curves*. This shows the *Curves* dialog where we have precise control over how pixels' original values are output.

Solarization and the Sabattier effect both refer to a partly reversed image, sometimes with Mackie lines around high-contrast areas.

3 Click the bottom left of the curve line and drag it to the top of the vertical axis. This tells Photoshop to output all pixels with a brightness value of 255. The image should now appear white.

5 Click and drag two more points on the curve so that it becomes a W shape. As you drag a point downwards, this darkens pixels by reducing their output value. The steeper the Ws dips, the more contrast there will be in those parts of the image. When you like the appearance of the image, click OK.

4 Click the middle of the curve line and drag it downwards so it is U-shaped. The image is now almost like a negative, but highlights are still brighter than midtones.

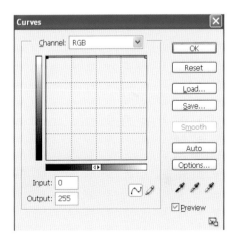

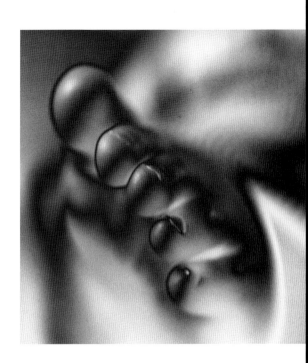

Simulating infrared film

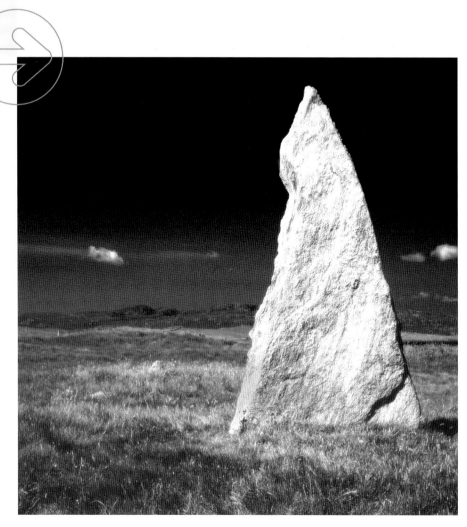

This standing stone from a Scottish stone circle stands out against a deep sky typical of IR photography.

Infrared (IR) photography uses special film, more sensitive to light in the infrared part of the spectrum. The film is usually loaded and unloaded in complete darkness, and a red filter over the lens cuts out non-IR light. Also, because IR-wavelength light focuses at a different point from visible light, focusing needs to be adjusted manually.

While some digital sensors are actually sensitive to IR, usually they incorporate a filter that eliminates it. Some cameras have an infrared setting, and it is worth experimenting, but read the manual carefully to see if it is a special effect rather than truly capturing IR. Try to get a specialist IR filter, or put a red filter on the camera lens and shoot in bright sunlight with foliage. You may get some very red pictures that, once they are in Photoshop, exhibit typical IR characteristics. There are many methods for making IR effects using Photoshop.

This method tries to replicate how IR film behaves: It lightens greens and reds, darkens blues, adds a lot of grain, and has that pale, ghostly quality so typical of infrared photography.

1 Unusually for this book, it is best to start off with a color image. To simulate IR glow, especially from foliage, Ctrl/Command-click the green channel in the *Channel* palette. Return to the *Layers* palette and click the layer containing the image. Make a copy of just the green channel, using the shortcut Ctrl/Command-J or the menu *Layer > Layer via Copy*. Set this layer's blend mode to *Lighten*. Then apply some blur using *Filters > Blur > Gaussian Blur*.

An infrared photograph is instantly recognizable: Blue skies become near-black, haze is eliminated, foliage is bright, and there is a strange, ghostly graininess.

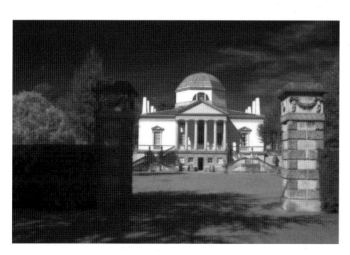

2 We need lighter foliage and near-black skies. Add a new *Channel Mixer* adjustment layer and check the *Monochrome* box. Leave red at 100, but make greens much lighter, with a value of 150 or more. Set a blue value of minus 100. Experiment with these sliders, making sure the highlights do not burn out and that the image retains cloud detail.

3 To add IR grain, create a new layer using *Layer > New Layer* or Shift+Ctrl/ Command+N. The mode should be *Overlay*, and check the *Fill with Overlay-neutral color* box. Click OK. Now add film grain to this overlay layer using *Filter > Artistic > Film Grain*. An alternative is to add noise instead.

TIP Try adding toning to a pseudo-IR image, and hand-coloring as well.

FACT FILE

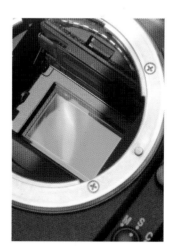

Infrared
Ⓐ Normally the human eye can detect light on the visible spectrum, with wavelengths of around 400-700mm.
Ⓑ Many digital cameras feature IR filters on their sensor to prevent IR interference in photo-taking, since silicon is sensitive to IR light in a way film is not.

4 Finally, adjust the opacity of the layers to fine-tune the effect.

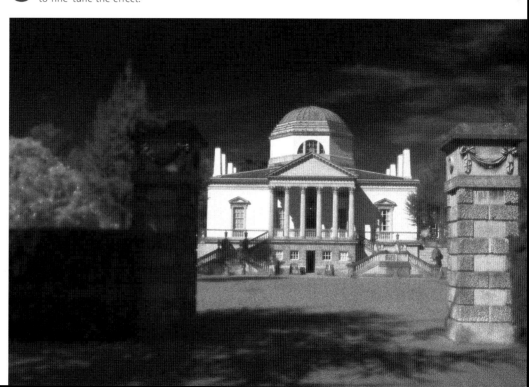

Reticulation and other texture effects

Reticulation is one of a number of ways of "distressing" an image. It is harder to achieve with modern films but is the result of sudden temperature change wrinkling film and making the grains gather in clumps. Darkroom workers also sometimes print two negatives onto one sheet of photographic paper, overlaying the main image with a texture such as cloth. These experimentations are part of darkroom work's continuing fascination. The addition of a filter can quickly produce interesting interpretations of a photograph. Once you begin using them selectively and in conjunction with other techniques, you soon find Photoshop is enabling your creativity to shine through.

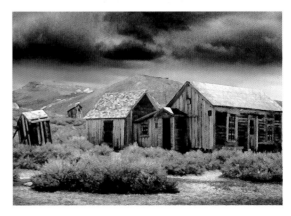

2 *Filters > Artistic > Paint daubs* was used with a brush size of 32 and high sharpness. A split-toning effect was then applied.

3 In this example, *Filters > Artistic > Palette Knife* was used with a size of 10. Some of the doors were then picked out and hand-colored.

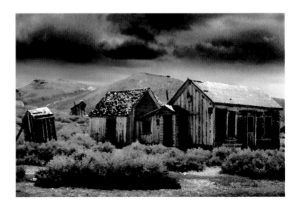

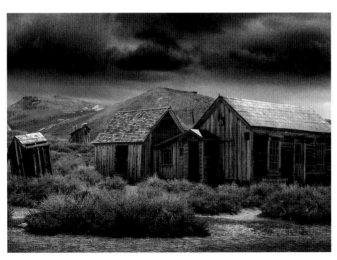

1 Settings for each picture need to be adjusted for the image size. Here the photograph of the ghost town's image was originally 2,525 by 1,648 pixels. *Filter > Sketch > Reticulation* produced a very dark image. An *Invert* adjustment layer was then added, and the levels were adjusted.

4 A *Mosaic* filter was applied with a tile size of 95 pixels. Sometimes it is interesting to hand-color individual tiles.

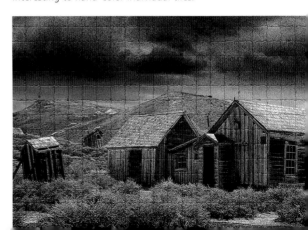

Photoshop includes a collection of filters designed to automatically change an image. They are quite intuitive, but try using them in combination or applying them to selected parts of an image.

Reticulation and other texture effects

TEXTURED FILTERS

With many of Photoshop's filters, such as *Distort > Glass*, you can choose from a built-in texture such as frosted glass. Alternatively, you can make your own. The texture can be a part of another photograph, a scan of an object such as art paper, or a Photoshop file created especially for the purpose.

You can load your own textures in many Photoshop filters, and even use them with tools like the Healing Brush.

TIP Copy items that you want to emphasize and place them on a layer above the filtered layer.

1 Create and save a texture file. It's best if this is saved as a Photoshop file with no layers. It doesn't need to be very big.

This fish came from scanning an Icelandic coin. You can create something in Photoshop like a simple gradient or a distorted chessboard.

2 Select the image layer you want to distort. Filters change the pixels to which they are applied, so make a duplicate of this layer. Apply the filter using *Filters > Distort > Glass.* Click the *Load Texture* arrow to the right of the *Texture* drop-down box. Adjust the *Distortion, Smoothness,* and *Scaling* sliders until you like the image, then click OK.

To simulate the view from the window of a harborside restaurant, the Distort > Glass *filter was used with the fish texture file.*

Bas relief and emboss effects

Unlike a true bas relief on the side of a building or a statue, a photographic bas relief has only an illusion of three-dimensionality. This is done by printing a slightly out-of-register sandwich of a positive and a negative copy of the image, but made on high-contrast lith film. It is a very easy effect to reproduce in Photoshop and, as usual, there is more than one way to do it. Other effects, such as *Embossing*, *Note Paper*, *Conte Crayon*, and *Charcoal*, use similar methods and are just as easy to try.

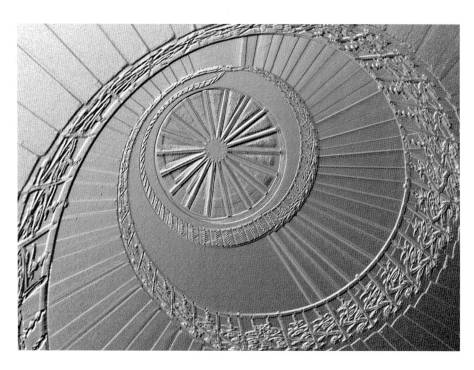

The bas-relief effect serves to provide a different interpretation of images, especially those composed of simple shapes.

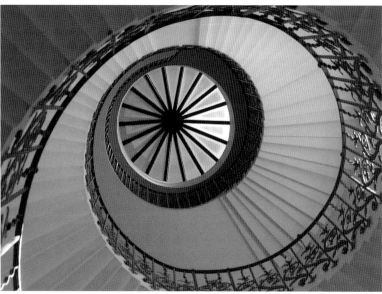

Because the image is being degraded so much, simple subjects often work better.

1 These effects change the pixels, so always work on a copy of the image layer. Sometimes it helps to flatten the image, so consider duplicating the current window by right-clicking its window bar.

2 The *Bas relief* filter uses the current foreground and background colors, whatever they are. So set them to black and white by pressing D.

Bas relief works well on many subjects, modern ones as well as those that hint at the technique's historical usage on walls.

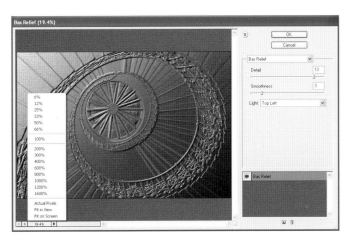
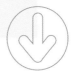

3 Click *Filters > Sketch > Bas relief.* Zoom in or out by clicking the percentage zoom button in the bottom left of the dialog box. You can also drag the preview image around.

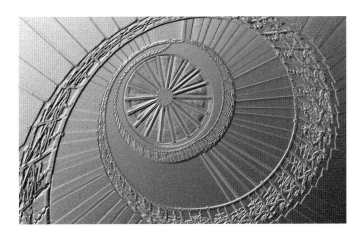

4 We are accustomed to seeing bas reliefs lit from above, so set the *Light* to *Top Left.* Move the *Detail* and *Smoothness* sliders until you like the image, and click OK. If required, adjust the image's *Levels.*

FACT FILE

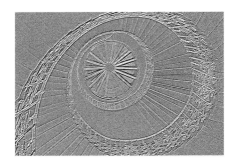

Embossing
The *Emboss* filter is very similar to bas relief and is found under *Filters > Stylize > Emboss.* Amount is often best set high—don't be afraid of pushing it up to 500— while height looks best at a low setting. This is a personal preference, however. Embossing a second time can bring out extra-fine detail.

This spiral image has been embossed twice.

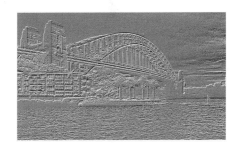

Another way to make a bas relief
Starting with a single-layer image, duplicate the image layer. Then select the original and make it appear negative by adding an *Invert* adjustment layer. Then add a *Threshold* adjustment layer to simulate the high contrast. Select the duplicate, which should be the top layer, make its opacity 50%, and finally move it slightly with the *Move* tool.

Two more images with clean lines: Sydney Harbor bridge and the London Underground.

TIP Destructive filters leave no record of their settings, but you can always label layers to remind you. Here, "BW" indicates black foreground and white background, *Bas relief* filter with *Detail* at 13, *Smoothness* 3, and lit from the top left.

Vignettes and borders

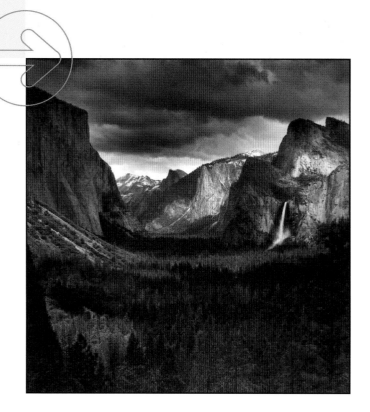

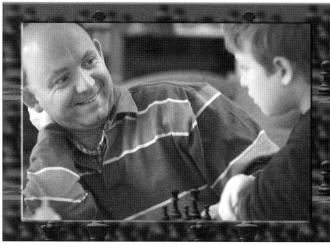

The simplest border is made by selecting the whole image, then using Edit > Stroke to *add a 1-pixel border in whatever color you choose.*

This border was created by painting it onto a new layer using the Pattern Stamp *tool, with a chess-piece pattern created beforehand.*

A vignette was originally a design of vine leaves, but in photography it usually refers to a photograph tightly cropped and inside a large, rounded border. Almost by definition, a vignette gives the subject an affectionate or nostalgic quality.

Making a vignette can be useful when a scene has distracting elements. I once took a candid shot of children hugging, but it was ruined by another little boy's unpleasant behavior and was only rescued by printing it as a vignette. Also, a composition may simply look good as a circular image—after all, digital imaging is not constrained to rectangles.

Some darkroom prints ostentatiously use the negative itself as a print border, including sprocket holes, frame numbers, and manufacturers' text codes. Digital imaging makes all such ideas easy for anyone to try.

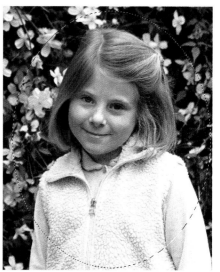

1 Select the top layer of the image and use Shift and M to start the *Elliptical Marquee* tool. Select the part of the picture that you want inside the vignette. If you hold down the Alt/Option key while doing so, the selection will spread outwards. If you also hold down the Shift key, the selection is constrained into a circle.

2 Now reverse your selection so that it's the part of the image you want to exclude. Use the shortcut Ctrl/Command+Shift+I. If you want, soften or feather the selection using the shortcut Ctrl/Cmd+Alt/Option+D.

A border, even a fine one, often seems to improve a picture, clearly defining the image.

3 Create a new blank layer with Ctrl/Command+ Shift+N.

> **TIP** → If you use Photoshop Elements, you can find a lot of pre-defined frames in the *Effects* palette.

4 Check that you can still see the selection's marching ants, and that the new blank layer is active. Set the foreground color, and use *Edit > Fill* or Alt/Option+ Backspace to fill the selected area with color.

 The selection was still active after the new layer was filled with white.

Edit > Stroke *and a color from the image was used to put a ring around the vignette.*

USING A FRAME

You can always give an image a border using your own frames. This gives you absolute creative control over the final look.

> **TIP** → Use the Q key to toggle the *Quick Mask* on and off and get a better idea of your selection.

1 Here are two images— a photograph of Yosemite and a scan of a medium-format negative with an empty center.

2 The layer containing the negative frame was dragged into the photograph.

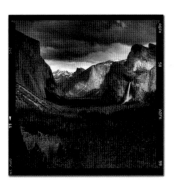

3 The photograph was then shrunk into the frame using *Edit > Transform* or Ctrl/Command+T. Holding down the Shift key kept the photograph's correct proportions.

Simulating multiple exposures

With a film camera, a multiple exposure could be made by stopping the film from winding on between pictures. But digital cameras generally take one picture per image file, so the multiple exposure needs to be assembled later on the computer.

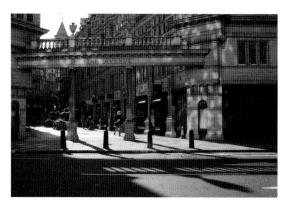

1 Shoot a series of images with the camera mounted on a tripod. Sometimes it helps to set the shutter, aperture, and focus manually—don't let them change. Open up all the images in Photoshop. Double-click the background layer and rename it—I used the file names. If you do the black and white conversion now, convert all the images in the same way. Click an image in the *Layers* palette, hold Shift (to center the image), and drag the layer into the next image's window.

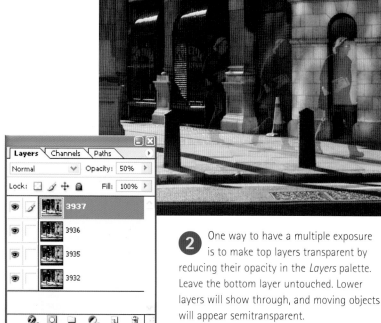

2 One way to have a multiple exposure is to make top layers transparent by reducing their opacity in the *Layers* palette. Leave the bottom layer untouched. Lower layers will show through, and moving objects will appear semitransparent.

The digital "multiple exposure," though a little time-consuming, creates fantastic results. It's a great opportunity for some surreal creativity.

3 If we want the moving objects to be solid, we need to use layer masks. Work on the top layer first. Set its opacity to 100%, and click the *Add Layer Mask* icon. It is often easiest to mask everything out, and then to reveal it. Make sure there is a small mask icon next to the thumbnail. Make the foreground color black (shortcut D, followed by X) and fill the mask with black. None of the layer is visible.

5 Repeat steps 5 and 6 down the layers—only the bottom image layer doesn't need masking. The final image consists of about 10 exposures, all masked. It is best to leave any cropping until the end.

TIP → If you normally shoot images in RAW mode, experiment with JPEG for multiple exposures. If they clear the camera buffer faster, you will be able to shoot more consecutive images.

4 Keeping the mask active, make the foreground color white (shortcut D). Use the brush to paint white onto the mask—where you paint, white will show through.

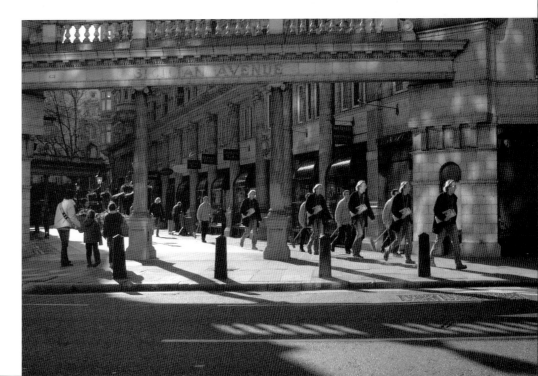

5 Showing and Sharing Your Pictures

There is one thing that the advent of digital photography has not changed: The fact that there is a final image to look at. Above all else, photography is to be shared, to be admired, criticized, and discussed. Digital presents us with a lot of options here, whether we choose to print our images, share them on the Internet, or even make a DVD. This chapter gives an insight into all those techniques, as well as a look at the technology to help you make really great black and white prints.

Perfect prints

With no border, snow on the ground makes this image bleed outward.

After capturing the right picture and working on it in the digital darkroom, the print's physical quality and finer resolution are much more satisfying than an image on screen. Final preparation, a good printer and ink combination, and right choice of paper can produce the true expression of the image.

TIP

There are growing numbers of online printing services. They print on color paper, so send black and white images in grayscale mode.

It often helps to add a thin border immediately before printing. Create a new layer, select all with Ctrl/Command+A, then *Edit > Stroke*—you can never go wrong with black. Other final preparation can include sharpening and burning the image edges with an overlay layer. If you are sharpening, remember that the effect on screen and the effect when printed are sometimes a little different (*see page 98*). Finally, you can also add a border to the print (but not file) from the *Print* dialog box.

Adding a border and doing some edge burning draw the viewer into the photograph.

Printing a black and white image on a color printer will probably result in your printer mixing colored inks to make grays—this is called gray component replacement.

CONTINUOUS FLOW SYSTEMS

Most photographers limit their printing because of the inconvenience, as well as the cost, of getting fresh cartridges. It may be worthwhile getting a printer to which you can later add a continuous flow system. Lyson and Permajet supply systems—consisting of ink bottles and tubes—that supply the inkjet cartridges. While there is an initial cost, running costs are much cheaper. But you do not have to do huge amounts of printing to justify the expense. A recent rough estimate was that if I use more than six full sets of cartridges over my printer's life, I would be better off investing in a continuous flow system. Also, quality not cost, is sometimes the issue. Both companies produce specialist black and white inks that offer better quality and archival life.

CHOOSING A PRINTER

A photographic inkjet printer costs more than a basic inkjet, but it offers the best balance of quality and affordability. Models are continually being updated and replaced. Before buying, read reviews in photographic magazines, get samples, try out friends' printers. Sometimes new models are first released in one country, and you can read users' opinions in online forums such as www.dpreview.com.

PRINTER DPI

Printer dpi, or dots per inch, is a measure of how many droplets per inch the inkjet puts on paper. Generally, the higher the number, the higher the quality, but 1440 dpi is good enough for most photographic printing.

TIP Check the resolution your camera defaults to (as opposed to the number of pixels). You may find it is not suitable for you.

It's not pretty, but continuous flow inks can save a good deal of money.

COLORS AND CARTRIDGES

The main choice is how many colors you want. Basic inkjets have four colors: Cyan, magenta, yellow, and black. Often the inks are in one cartridge, which has to be replaced as soon as one color runs dry.

For better photographic quality, look at printers with six to eight colors, usually in separate cartridges. Light cyan and magenta inks improve color rendition, and some printers get better tonal quality with a light black cartridge.

IMAGE SIZE AND RESOLUTION

If a digital image is 3,000 pixels wide, its normal printing width is 10 inches. This is because at 300 pixels per inch, the image is so finely resolved that the eye usually sees a continuous tone. Normally, this resolution is measured in dots per inch (in this case, 300 dpi). If you want to print something larger, you can reduce the image resolution. Print the same 3,000 pixel image at 100 dpi, and it would be 30 inches wide. At a normal viewing distance, the eye detects the pixels, but large images are viewed from further away, so the lower resolution may be acceptable. So think about how the image will be viewed when you decide how large to print it.

Special black and grayscale inks

Domestic inkjet printers, even the best, are not ideally suited to producing fine black and white prints. Depending on their driver software, they may mix all their inks in order to create some shades of gray, which can lead to muddy browns or imperfect colors. If you know you will be producing a lot of black and white prints, then it is worth investing in a dedicated system, some of which are emerging on the market. Aside from quality, these might employ continuous inkflow systems to reduce the chance of running out mid-print. Finally, you will want to consider ways you can improve your monitor's accuracy, including calibration. There are options to suit any budget, from an onscreen wizard to paying a professional to examine your system and set up the perfect workflow.

TIP Scan your signature and add it to special prints—though be careful about security.

This combination of inks can be used with a continuous flow system (like that pictured on page 126) to create a rich black and white tonal range.

BLACK AND WHITE INKS

Inkjet printers output black and white images using all their colors. There is usually a faint color cast. If the printer only used black, the tonal range would be lower. There are special black and white inks from companies such as Lyson and Permajet, which allow you to produce the full grayscale tonal range.

DYES AND PIGMENTS

While most inks are dye-based, see if pigment-based inks are available for your printer. Dyes can fade, sometimes quickly, depending on lighting, storage, and atmospheric conditions. Pigment-based inks offer archival life. They coat the paper surface rather than soak into it, so they were once less suitable for glossy paper, but now some printers have an extra gloss cartridge. If you hope to sell your pictures, or simply want them to last a lifetime, you need archival stability.

ART PAPERS

Experiment with papers other than those marketed by the printer manufacturer, which are usually very ordinary. "Art" papers can have much greater weight, creamy off-white base colors, or textured surfaces. The range is huge and continually changing, and sometimes you can get test packs of 20 sheets of different types. A print on such paper can feel and look much more special.

ICC PROFILES AND CALIBRATION

Even with the printer manufacturer's own inks and papers, the print may differ from the image on the monitor. One solution is to add a *Curves* adjustment layer—this could be recorded as an Action. You might also adjust your monitor to match the prints. The real solution is to start employing color management. This method uses ICC profiles, or color characteristics, of each step in the digital-imaging process. Profiles for the device, such as the scanner or monitor, and also for each combination of printer, ink and paper. Using these profiles, Photoshop can match colors exactly.

Check your Color Settings *in the* Preferences *dialog.*

One way to ensure reliable images, if the light isn't changing, is to shoot a sheet of neutral (white/gray) card using your camera's white balance set-up option.

As an alternative to a colorometer, you can use the Adobe Gamma Wizard to set up your monitor. Adobe applications install this in your Windows Control Panel. Macintosh computers have a similar dialog in the System Preferences.

MONITOR CALIBRATION

You can create an ICC profile for your monitor using Adobe Gamma. In the Windows Control Panel, double-click the Adobe Gamma icon and use the wizard. Alternatively, there are professional calibration devices such as the Spyder, or specialists who can create ICC profiles for you.

PRINTER AND PAPER CALIBRATION

In the printer dialog, you can also set advanced options. In the *Print with Preview* dialog box, check the *Show More Options* box. Make sure the drop-down box shows *Color Management*, not *Output*, and you can then specify the color profiles to use for more precise printing.

A monitor supplied with its own colorometer, which allows it to calibrate itself for ideal color reproduction.

PRINTER PROFILES

Each paper/ink/printer combination is different, and you should ideally have an ICC profile for each one. Some paper and ink manufacturers supply ICC profiles, and there are third-party profiles on the Web. You can also develop your own using profiling tools such as Profile Prism, MonacoEZcolor, or the freeware program xlprofiler, which allow you to create profiles to meet your exact needs and environment.

Digital photo essays

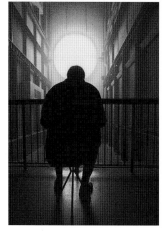

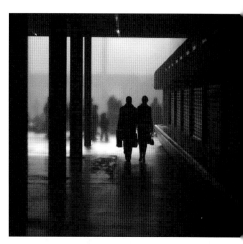

Placed together, similarly cropped photographs can add up to a study of an individual, or the same scene at different times of the year can become a commentary on the seasons. Or a collection's common theme may make a point or document something and say more than a single good picture would have done on its own. Shoot new images or revisit old ones, maybe making them black and white or cropping them differently.

1 Return to a scene and reshoot images that you nearly got right on previous visits. Most skills improve with practice, and this helps you think more deeply about what works. Each time you will understand more about the scene and the light, improve on your previous visits, and force yourself to find different perspectives.

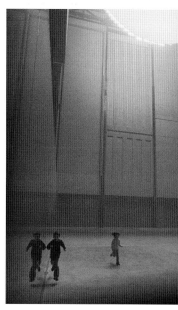

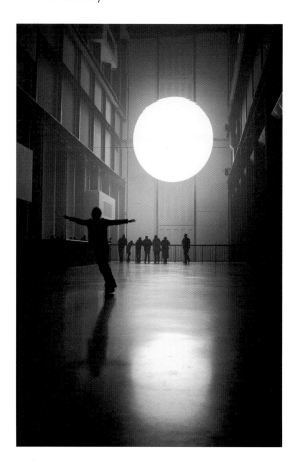

Trying to capture reactions to the artificial sun and mist in London's Tate Modern gallery, the color image was shot on my second visit and remains my favorite. It works well in monochrome, but also when shown as the sole color image in the project. Later visits produced many other viewpoints, even an ironic comment on the gallery's ban on the use of photographic tripods.

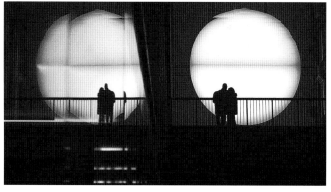

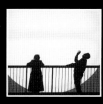 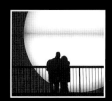

Putting together an album or presentation, or building a photographic essay, are both impressive ways to show your work and a way to drive your photography forward.

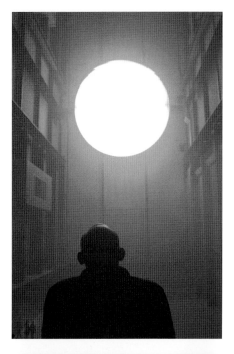

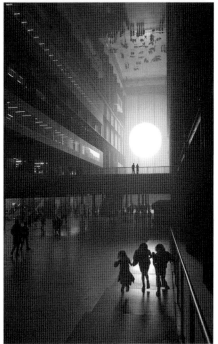

2 Even if they already know the photographer, people need to have confidence in you, and you must be sensitive to their feelings. Children in particular need time to adjust to the camera's presence.

TIP Make sure you know your camera's burst limit so you don't miss a shot.

3 If your project involves people, take advantage of digital photography's interactive nature. A single candid photograph shown to its subject led to a series of portraits of the people of Tropea in Calabria, where I wrote part of this book. This man agreed to a portrait, but insisted that his friend also pose for me. Both photographer and subject need confidence, so work quickly, show the LCD, and explain what you are doing. This makes it easier to ask for another few shots if the first ones are not quite right. Lastly, keep promises to send copies of the pictures.

Slideshows on CD-ROM

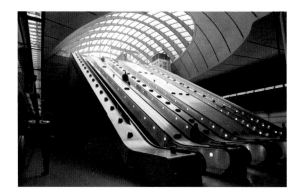

Another way to share your pictures is to put the files into a slideshow on CD. Fortunately, many software packages have wizards to automatically do this for us and save the result in a popular format. Try out such features in Photoshop, your digital camera's software, and your CD-burning package.

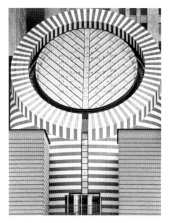

Here is a collection of architectural images that need to be shared via CD.

Here, we are going to generate a slideshow with standard backgrounds, text annotations, and a navigation system. We will use a Web style so that it will run on any computer, but we want to press a button and leave the rest to a wizard.

1 In Photoshop, select *File > Automate > Web Photo Gallery*. The first options to set are the style, where the images are, and where they should be sent. At this point, you could just click OK and wait until the job has finished and you can burn the CD.

3 *Large Images* is the most interesting option. As we are going to burn this slideshow to CD, we may as well have maximum quality. And set a custom size—450 is quite small.

4 Below these quality and size settings are a number of boxes. If you check them, data from the image file's *File Info* will be written into the slideshow.

2 To get more out of this wizard, the key is use to the *Options* drop-down box. First change the *Banner*—this text will appear in every page of this slideshow of architectural shapes.

TIP If you feel confident about editing HTML, you can create your own templates. In its program directory, Photoshop has a *Presets/Web Photo Gallery* and a folder for each template style. Copy a style, then edit in a text editor like Notepad.

SHOWING AND SHARING YOUR PICTURES

It's very simple to present your images on CD these days, especially since you can make Web files which are compatible with all the dominant computer systems.

5 Experiment with the custom colors, thumbnail size, and security options. I changed the banner color here.

6 You can burn the folder Photoshop created to CD. Just tell users to double-click the file called "index.htm." As we have just created a Web page, you can even upload it to any Web space you may have.

```
[autorun]
shellexecute=index.htm
label=architectural shapes
```

7 A further refinement is to add a text file to automatically run the slideshow in the user's browser. For Windows, this must be named "autorun.inf" and should be saved in the same folder as index.htm.

The shell line tells Windows to run the default program for the index.htm file.

TIP If you're sending the CD out to people, consider supplying the full-size image files on the disc as well as the Web-quality slide show. That way, they can choose to view or print at a higher quality. Only do this if you're confident they will not infringe your copyright, though.

FACT FILE

Other applications

There are other applications around that allow you to create slideshows of your images. If you have an Apple computer, for example, you can use iPhoto to create instant slideshows on your desktop, complete with transitions and music. Windows users might consider Photoshop Album as an alternative, since it has very similar functions.

Multimedia DVDs

A multimedia DVD, which can be played on TVs as well as computers, is another good way to share your photographs. Digital images can be big files, but sound and moving pictures require much more space and exploit DVD's great storage capacity.

Photoshop can prepare the images, which should be saved in JPEG or TIFF format. You will need other software to prepare the sound and video, and to "author" a professional DVD presentation. You have three choices: Software you may already have, freeware or shareware packages, and full-blown professional tools.

You may already have the programs

Windows XP includes a basic movie maker that lets you add pictures, sound, and video. When you save the file, select the *Other* format—this gives you the possibility of exporting to many video formats. If you have Microsoft Office, particularly PowerPoint, this can be used for a presentation that can sound and look very sophisticated. Investigate the software supplied with your digital camera. Movie cameras often include a basic multimedia package that will allow you to incorporate still images into your presentation.

Look closely at your CD/DVD burning software, such as Easy and Nero. Recent versions include storyboard-style wizards for assembling multimedia DVDs. You can often customize the results by locating and editing the templates in their program directories.

Sound

To prepare the sound clips, you will need some sort of audio-editing package. There is Adobe Audition, a full-featured professional tool formerly known as Cool Edit. Recent versions of CD/DVD creators, such as Nero and Roxio Easy Creator, include basic sound editors. But your needs may be met by a shareware program such as Wave Repair, a fine tool for transferring music from vinyl to CD. Save the files in a common format such as MIDI, WAV, MP3, or WMA.

Video

For video, consider programs such as Adobe Premiere and Apple's Final Cut. Save in a format such as MOV or MPEG.

Authoring

"Authoring" refers to assembling the final DVD presentation, which includes making a simple interface, assembling all the different types, and boiling everything down into the right video format. This can either be achieved using a wizard-based application, or by dedicated professional packages, giving a great deal of control but sacrificing speed. Nero on the PC has some DVD creation wizards, and Macintosh computers with a built in "Superdrive" (Apple's term for a DVD burner) come with the very elegant iDVD as standard.

Professional programs for creating presentations include Macromedia Director and Macromedia Flash, while Apple users have these and Keynote at their disposal. DVD Studio Pro (Mac) and Adobe Encore (Windows) can both be employed to create advanced DVD menus which work in any DVD player.

TIP One of the best ways to learn new software is by starting with a clear idea of what you want to create. So define what you want to do, and take full advantage of software manufacturers' 30-day free trials.

1 If you have Microsoft PowerPoint, you can make a multimedia presentation using your photographs. An alternative is to use Impress from Open Office, the free Open Source rival to Microsoft Office.

2 Customize one of the built-in templates by selecting *View > Master > Slide Master*. Here, a series of images was added to the background and formatted to appear washed out.

Slide Transition

Apply to selected slides:

- No Transition
- Blinds Horizontal
- Blinds Vertical
- Box In
- Box Out
- Checkerboard Across
- Checkerboard Down

3 Each slide can have sound effects that begin as soon as it appears—look at *Slide > Slideshow Transition*. You can also right-click images and set them so you can start sound clips or videos by clicking them during the presentation.

4 *File > Pack* and Go allows you to export a "run time" version of the PowerPoint presentation. This can be burned onto a DVD and run on another Windows machine, even if it does not have PowerPoint installed.

5 *File > Save As* lets you export the PowerPoint slides to TIFF or other image formats that can then be used by a DVD-burning software's wizard.

For over a decade, London's Speakers' Corner has been a rich source of photographs for me. Every Sunday, people gather to express their views, some crazy, many deluded, some fascinating. It's a great audiovisual experience.

FACT FILE

iMovie and iDVD

If you have a Macintosh computer, you can create a slideshow using the built-in iMovie tool. One excellent feature is the ability to zoom in and out on an area of your choice, much like TV documentaries. Indeed Apple calls the effect "the Ken Burns effect."

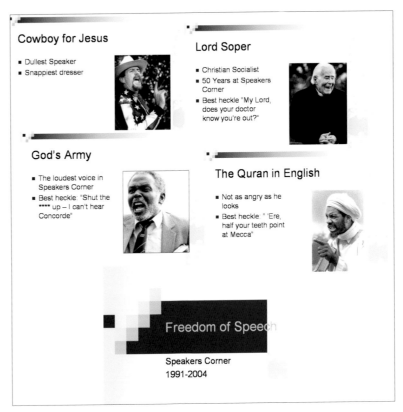

Cowboy for Jesus
- Dullest Speaker
- Snappiest dresser

Lord Soper
- Christian Socialist
- 50 Years at Speakers Corner
- Best heckle "My Lord, does your doctor know you're out?"

God's Army
- The loudest voice in Speakers Corner
- Best heckle: "Shut the **** up – I can't hear Concorde"

The Quran in English
- Not as angry as he looks
- Best heckle: " 'Ere, half your teeth point at Mecca"

Freedom of Speech

Speakers Corner
1991-2004

Putting pictures on the Web

Pbase offers free 30-day trials. This, with 50 other existing images, took under 30 minutes to set up and needed no special skill.

There are many ways to share your photographs by putting them on the Web. Building your own site can be as simple as generating it with Photoshop's *File > Automate > Web Photo Gallery*, or it could involve using a similar feature in a professional website design package such as Macromedia Dreamweaver. Then you just need to upload the files to your Web space and invite people to have a look.

If you do not want to build your own site, a popular way to share your work online is by joining online photographic communities such as pbase and photosig. These provide storage space and simple screens to upload pictures, add descriptions, and group images into galleries. Thumbnails and links are generated automatically, and members are listed by location, camera type, country, sometimes even at random. Viewers can add their comments, which are usually helpful and encouraging.

1 Resize the picture, because viewers are unlikely to have screens more than 1,000 pixels high, and big files take longer to download. Be consistent, too—for instance, use 800 pixels as the width for all images in landscape format, and as the height for those in portrait format. Sharpen the image using *Filters > Unsharp Mask*, and maybe add copyright text in one corner.

When you are putting images on the Web, you should always remain aware of your audience. If, for example, they all use slow modems, make the files very small.

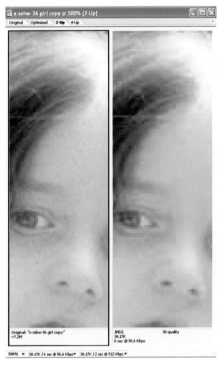

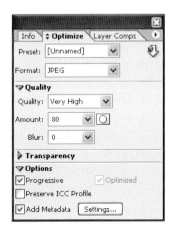

3 The trick with JPEGs is to speed up download by compressing the file, but without sacrificing too much quality. Select the *Optimize* palette and adjust the *Quality* setting. The 2Up window shows that high compression has added pink artifacts around the nose and eyes in this sepia-toned image.

4 At the bottom of the window are two indications of how long the image will take to download. Make sure these are for the most likely connection types. Here, the image will become a 253k JPEG. This is large for the Web and will take most visitors 47 seconds to download on a normal internet connections. Ask yourself—would you wait that long? This image needs to be smaller, or the file needs to be more compressed.

5 The *Optimize* palette also has a check box for this "metadata." This is the EXIF data. In *File > Output Settings*, you can also set the default options for saving EXIF information with the JPEG file.

6 When you have a good quality-size balance, save your file using *File > Save Optimized*. Use lower-case letters for the filenames, "_" instead of spaces, and avoid characters such as "&". Many Web servers and browsers are case sensitive or treat spaces differently.

2 Photoshop has three main ways to save in JPEG format. Avoid *File > Save As*, because it gives no preview options. If EXIF data is important to you, also avoid *File > Save for Web*, because this usually strips the data from the JPEG file. This is unfortunate, because EXIF data is readable by Windows Explorer, Photoshop CS's File Browser, and image-cataloging software, and can be added automatically to Web pages. The best choice is Photoshop's Image Ready program. This is under the *File* menu and is an icon at the bottom of Photoshop's toolbox.

TIP After resizing and sharpening a picture for the Web, it is easy to overwrite your original. So work on a duplicate of the image file.

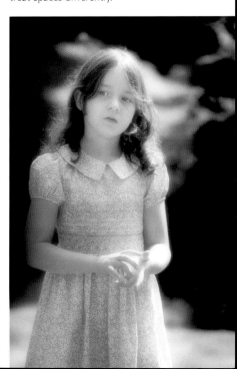

Glossary

action Keystrokes recorded in Photoshop and used to automate routine activity.

acutance A measure of the difference between neighboring brightness levels and the major factor in the apparent sharpness of an image.

adjustment layer An editable layer in a Photoshop image that adjusts the appearance of layers beneath it.

AE lock A camera button that the user presses to keep an exposure reading fixed while the picture is being recomposed. It is often used to set the exposure using a mid-toned object outside the frame and when the photographer considers the subject's color or illumination might mislead the camera.

aliasing Jagged edges in a digital image, caused by pixels' square shapes.

alpha channel A grayscale version of the image that can be used with the color channels for saving a mask or selection. It is often used to define an image's level of transparency at each pixel.

anti-aliasing Smoothing jagged edges by introducing additional pixels of intermediate tone.

aperture Adjustable circular hold in the lens, used to control the passage of light.

aperture priority Exposure mode on a camera where the user sets the aperture, leaving the camera to set the necessary shutter speed.

application Software designed to make the computer perform a specific task. An image-editing program is an application, as is a word processor.

artifact Foreign shapes degrading a digital image as a result of its capture, manipulation, or output. This is a common effect of strong file compression.

bitmap An image consisting of a grid of tiny pixels, each with color and brightness values. When viewed at actual pixel size or less, the image resembles a continuous tone shot, like a photograph.

blend mode How a Photoshop layer blends into layers beneath it.

blown out An image or area containing no detail, usually referring to overexposed parts of an image.

brightness Subjective impression of luminosity.

bronzing The visible texture of ink on an inkjet print, often the result of a pigment-based ink drying on the surface of glossy paper rather than being absorbed like a dye-based ink.

burn A photographic darkroom and Photoshop technique to darken part of the image.

burning In reference to computers, this usually refers to the process of creating a CD or DVD using your computer, since this involves a laser "burning" the disc to leave small marks, or pits.

burnt out A photograph or area of one containing no detail, usually referring to overexposed parts of an image.

burst A rapid succession of shutter releases. As digital cameras need to move data from the CCD to the storage card, which can take a few moments, there is often a maximim number of frames that can be taken in any given burst.

camera raw In Photoshop CS, the module responsible for converting RAW images from a digital camera.

CCD Charge Coupled Device. A light sensitive electronic sensor, the component of your camera onto which the lens focuses the image.

CD Compact Disc. Optical storage medium. As well as the read-only CD-ROM format, used by most computers to install applications, there are two recordable CD formats. On a CD-R (Compact Disc-Recordable), each area of the disc can only be written to once, although it's possible to keep adding data in different "sessions." On a CD-RW (Compact Disc Rewritable) the data can be overwritten many times.

Channels Each color in a digital camera: Red, green, and blue.

cloning In an image-editing program, the process of duplicating pixels from one part of an image to another.

CMOS Complimentary Metal Oxide Semiconductor. A light sensor that capture images taken by digital cameras, as opposed to a CCD. Kodak and Canon both employ this technology.

CMYK Cyan Magenta Yellow Key. The four colors used in color printing. Theoretically there is little need for "key" (black), but in reality it is difficult to get the other inks to mix to produce a good black, and even if they do there can be too high a concentration of ink on the paper, causing it to tear.

compact flash A type of memory card. There are two types of "CF" cards, as they are known—type 1 and type 2. A type 2 slot is wider, enabling it to take a 5mm thick "microdrive" as well as a type 1 CF card.

compression A method for reducing the size of image files, using computer algorithms. This can be either "lossy" compression, which discards information and can have a dramatic effect on file size, or a method like LZW, which maintains detail but simply adds processing time when files are loaded.

continuous flow systems A system of bottles and tubes that supplies ink to an ink-jet printer, as opposed to the manufacturer's cartridges.

continuous-tone image An image, such as a photograph, in which there is a smooth progression of tones between black and white.

contrast Difference in brightness between neighboring areas.

curves In Photoshop, a method of mapping pixels' brightness values to the value at which they are output.

default The standard setting or action used by an application unless deliberately changed by the user.

depth of field The area in acceptable focus, in front of and behind the point at which the lens is focused, and varied by opening and closing the aperture.

destructive editing Permanent changes of pixels' brightness values or positions, this is as opposed to changes made using, for example, Photoshop's Layers tool or Masks, which can simply be undone.

diffusion The scattering of light by a material, resulting in a softening of the light and of any shadows cast. Diffusion occurs in nature through mist and cloud-cover, and can also be simulated in professional lighting set-ups using diffusion sheets and soft-boxes.

digital A way of representing any form of information in numerical form as a number of distinct units. A digital image needs a very large number of units so that it appears as a continuous-tone image to the eye; when it is displayed these are in the form of pixels.

dithering A technique used to create an illusion of true-color and continuous tone in situations where only a few colors are actually used. By arranging tiny dots of four or more colors into complex patterns, the printer or display produces an appearance of there being more than 16 million visible colors.

dodge A photographic darkroom and Photoshop technique to lighten part of the image.

DPI Dots Per Inch. The standard measure of resolution, though this is more correctly described as PPI on computer screens.

dye A type of ink that soaks into the paper.

edge burning Subtly darkening a picture's edges in order to draw and hold the viewer's attention on the image.

EFL Equivalent Focal Length. Since digital cameras have different size sensors, the focal length for traditional lenses varies (see focal length multiplier). For convenience, an EFL is a focal length written as the equivalent of 35mm.

enlarger Darkroom equipment for projecting a negative onto photographic paper.

EXIF Commonly refers to exposure information stored with digital image files, strictly refers to the file format.

exposure compensation Overriding the exposure settings calculated by the camera, usually measured in fractions of stops (for example +0.3, -0.7).

F stop The ratio of the focal length to the aperture diameter, expressed as f2.8, f4 etc.

feathering In Photoshop, making the edges of a selection softer.

film grain The appearance in a black and white photograph of the negative's silver halide crystals, variable in size and sharpness and depending on film type and development. With a digital image this may be simulated in Photoshop.

filter (in photography) Transparent material which changes the light passing through it. Placed in front of the lens.

filter (in Photoshop) A Photoshop change applied to pixels in the active layer or selection. This is a destructive editing method.

firmware The software that runs a device such as a camera or portable hard disc, which can sometimes be upgraded to improve the device's features and performance.

flash memory The form of computer memory used in a digital camera's storage card, which maintains its data when there is no current.

focal length The distance between the center of the lens and the focal point.

focal length multiplier The change to the effective focal length of a lens designed for 35mm cameras, when it is mounted on a digital camera. Usually a value of around 1.5, depending on the size of the image sensor.

focal point The point at which light rays passing through a lens converge.

focus Where light rays converge on the sensor and form a sharp image.

full manual Exposure mode on a camera where the user sets both the shutter speed and the aperture.

gamma A measure of contrast in a digital image, a photographic film or paper, or a processing technique.

gradient Smooth blending of one color to another.

grayscale An image containing shades of gray as well as black and white.

high key A photograph whose appearance is dominated by light tones and few dark or shadow areas.

highlight The brightest areas of an image.

histogram A chart showing the distribution of pixels by brightness value.

hue The pure color defined by position on the color spectrum; what is generally meant by "color" in lay terms.

ICC International Color Consortium. A standards setting body.

ICC profile A measure of a digital imaging device's color characteristics, used for accurate communication of color between devices.

Glossary

image-editing program Software that makes it possible to enhance and alter a digital image.

image mode Method of recording color and brightness in a digital image file.

interpolation The addition or deletion of pixels when the computer resizes an image.

ISO Industry Standards Organization. The ISO settings refered to by photographers are a measure of sensitivity to light ("speed") as set by the organization.

JPEG A digital image file format which compresses file size by the removal of unused color data. The user can select the extent to which image detail is sacrificed.

Lasso tool A Photoshop tool to select image areas.

layer *(in image editing)* A level of the image file to which changes can be independently applied, a little like working on multiple acetate sheets.

LCD Liquid crystal display, used to refer to the screen on the back of digital cameras.

lith A type of darkroom print produced by special combinations of paper and development, characterized by strong shadows and soft highlights and midtones.

lossy A file format which loses image information in order to compress file size; opposite of lossless. JPEG is a lossy format, TIFF is lossless.

low key A photograph consisting of mainly dark or shadow tones and few highlights.

luminosity The quantity of light reflected by or emitted from a surface.

Macintosh computer Apple Computer's alternative to the more common Windows-based computer systems. "Macs" are traditionally favored by the design community, though for the majority of computing tasks neither Windows or Mac OS have a significant technical advantage.

macro A type of lens capable of close and more than 1:1 magnification.

marquee A Photoshop tool to select image areas.

masking Blocking parts of an image from light, or in Photoshop excluding parts of layers from an image.

megapixel A million pixels, usually used as a measure of the sensor of digital cameras.

metamerism Subtle and unwanted color casts that only become visible in black and white inkjet prints under certain lighting conditions, commonly magenta in tungsten light or green in daylight.

metering Measuring the amount of light in the frame and calculating the correct exposure for the scene.

microdrive A small hard drive used as camera memory, fitting into a compact flash type 2 slot. Their advantage—greater storage capacity—is steadily being eroded by the arrival of greater capacity traditional flash-memory cards.

midtone The average luminosity parts of a digital image.

mode One of a number of alternative operating conditions for a program. For instance, in an image-editing program, color and grayscale are two possible modes.

neutral density Uniform density across the visible wavelength and of no color.

noise Random pixels on a digital image.

Paint Shop Pro A popular image editing application on Windows computers, from JASC. It has many of the features of Photoshop, and a few Photoshop doesn't, but arguably has a less polished user interface, making it harder to use. Popular among Web designers.

pallete In image editing applications, a small window containing tools allowing you to work on a certain aspect of your image. These can be moved around the screen, or hidden, to suit your workflow.

paste Placing a copied image or digital element into an open file. In image-editing programs, this normally takes place in a new layer.

Photoshop Image editing application, for Mac or Windows, which has become an industry standard amongst graphics professionals and image editors. It is sold separately, or as part of a stable of design applications, by Adobe.

Photoshop Elements A cut-down version of Photoshop, lacking its RAW file support, some masking features, and the ability to work in CMYK. It is, however, much cheaper and still provides a large proportion of the features of its sibling, especially those of use to amateur digital photographers.

pigment A type of ink consisting of particles that lie on top of the paper.

pixel PICture ELement. The smallest unit of a digital image.

plug-in Software produced by a third party and intended to supplement a program's performance.

RAW The native file format in which an image is stored by some digital cameras. Sometimes refered to as the "digital negative," it stores every detail the camera takes, including settings. This gives you the opportunity to change it later, but each camera produces its own unique RAW file. These need to be processed before image editing can take place.

resampling Changing the number of pixels in an image.

resolution The level of detail in an image, measured in pixels or dots per inch.

RGB The primary colors of the additive color model, used for recording image colors on monitors and for image editing.

Sabattier effect Partial reversal on tone due to exposure of photographic emulsion to light during development.

saturation The purity of color, with high saturation being most intense, and a desaturated area having no color value whatsoever (a gray shade).

scanner Device that converts film or flat artwork into a digital image.

shadow The darkest areas of an image, as opposed to highlights.

sharpness A combination of resolution and acutance, and a measure of apparent clarity of detail in an image.

shutter The mechanical device inside a conventional camera that controls the length of time during which the sensor is exposed to light. Many digital cameras don't have a shutter as such, but the term is still used as shorthand to describe the electronic mechanism that controls the length of exposure for the CCD.

shutter lag The time delay between pressing the shutter release on a digital camera and the exposure being made. The length of this delay was a problem with early digital cameras.

shutter priority Exposure mode on a camera where the user sets the shutter speed, leaving the camera to set the necessary aperture.

shutter speed The amount of time that the shutter is open, exposing the sensor to light.

SLR Single Lens Reflex. A camera that shows the same image directly through the viewfinder as on the sensor or film.

solarization Usually the same as the Sabattier effect but strictly an effect caused by greatly over-exposing film emulsion.

split toning Applying more than one tone to a black and white print, often with one tone in the shadows and another in the highlights.

spot meter A specialized light meter, or function of the camera light meter, that takes an exposure reading for a precise area of a scene. This is particularly useful for ensuring that vital parts of the scene are correctly exposed.

stop See f-stop; also used as the action of closing the aperture as in "stop down."

thumbnail Miniature on-screen representation of an image file.

TIFF Tagged Image File Format, a file format for high-resolution graphics, widely compatible with many operating systems. This is normally a lossless file format, preserving all image data (but not camera information like the camera-specific RAW formats).

toning *(in the darkroom)* A darkroom process by which a black and white print is immersed in a chemical that changes the color of the silver halides in the paper. Common tones are sepia and blue but other toners such as selenium and gold can be used for widely differing effects.

toning *(in Photoshop)* Applying a color cast to a black and white image.

toolbox An area of the screen used to provide immediate access to the most frequently used tools, settings, and commands.

tool options bar *(in Photoshop)* The bar along the top of the screen in Photoshop that allows you to fine-tune whichever tool you have selected from the toolbox.

TWAIN A standard that allows graphics applications, like Photoshop, to access information from a device—such as a camera or digital camera. When a TWAIN device is installed, it will become visible to compatible applications. In Photoshop, for example, the File > Import > menu includes a list of TWAIN devices.

unsharp mask A process that increases the apparent detail of an image by computer manipulation.

Windows Microsoft's dominant computer operating system, a variant of which is installed on around 90% of the world's personal computers. Most image-editing applications, even though with a history on the Macintosh, are available for Windows.

white balance Automatic compensation for the color temperature of artificial light.

zoom Lens with a variable focal length. This makes framing your photograph easier, though there are more lens elements to a zoom than a fixed, or prime, lens.

Index

Acknowledgments

Thanks to Alan Buckingham for giving me the opportunity to write this book, and to Adam Juniper at Ilex for his guidance and patience.

I dedicate the book to my mother, for her continuing inspiration, and want to thank my friends and family for their encouragement and tolerance over the years. Particular thanks are due to Sandra Gallippi for letting me use the house in Tropea, Calabria during the writing of the book, and to the lovely people of Tropea whose photographs it was a pleasure to take.

Useful Addresses

Adobe (Photoshop, Illustrator)
www.adobe.com
Alien Skin (Photoshop Plug-ins)
www.alienskin.com
Apple Computer www.apple.com
Association of Photographers (UK)
www.the-aop.org
British Journal of Photography
www.bjphoto.co.uk
Compact flash performance database
www.robgalbraith.com
Corel www.corel.com
Digital camera information
www.photo.askey.net
Digital Photo Review www.dpreview.com
Epson www.epson.co.uk www.epson.com
Extensis www.extensis.com
Formac www.formac.com
Fujifilm www.fujifilm.com
Hasselblad www.hasselblad.se
Iomega www.iomega.com
Kingston (memory) www.kingston.com
Kodak www.kodak.com
LaCie www.lacie.com
Lexmark www.lexmark.co.uk
Linotype www.linotype.org
Luminos (paper and processes)
www.luminos.com
Lyson www.lyson.com
Macromedia (Director)
www.macromedia.com

Microsoft www.microsoft.com
Minolta www.minolta.com
www.minoltausa.com
Nikon www.nikon.com
Nixvue www.nixvue.com
Olympus
www.olympus.co.uk
www.olympusamerica.com
Open Source directory sourceforge.net
Paintshop Pro www.jasc.com
Pantone www.pantone.com
Pbase www.pbase.com/
Permajet www.permajet.com
Photographic information site
www.ephotozine.com
Photoshop tutorial sites
www.planetphotoshop.com
www.ultimate-photoshop.com
Polaroid www.polaroid.com
Qimage Pro
www.ddisoftware.com/qimage
Ricoh www.ricoh-europe.com
Russell Brown www.russellbrown.com
Samsung www.samsung.com
Sanyo www.sanyo.co.jp
Shutterfly (Digital Prints via the Web)
www.shutterfly.com
Sony www.sony.com
Symantec www.symantec.com
Umax www.umax.com
Wacom www.wacom.com